IMAGES OF AMERICA

ATLANTIC HIGHLANDS

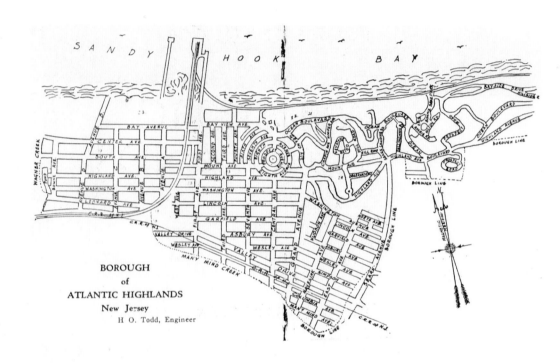

BOROUGH
of
ATLANTIC HIGHLANDS
New Jersey
H O. Todd, Engineer

This map, from a *c.* late 1920s business directory, is remarkably clear and illustrative for a small scale plan. The borough's water borders and the circuitous land lines on the southeast are marked with dotted lines. The Mandalay pier at the Atlantic Beach Amusement Park, on the shore at left, is adjacent to the more often illustrated Central Railroad pier. Note that the track going east to Highlands was on the water prior to the construction of the harbor. Also note the Bayshore branch entering town at lower left and the old line that went to Stone Church (Navesink) and beyond. The circle at center and the streets to the west show the unusual layout of the numbered avenues. Rather than the expected grid, First and Third run to the border, while Second and Fourth are a block long; all four run north-south. However, Fifth (not labeled here), Sixth, and Seventh are arcs of varying length, while only Eighth is a circle (see bottom of p. 121). The foot of today's Ocean Boulevard was then Bay View Avenue; I have referred to that stem throughout the book by today's name. First-time travelers on Mount may be surprised to find themselves on an elevated street bridge at Grand. The diagram on p. 14 illustrates what the map cannot.

IMAGES OF AMERICA

ATLANTIC HIGHLANDS

RANDALL GABRIELAN

ARCADIA

I dedicate this book to my good friend the Honorable Robert A. Schoeffling. Bob has long been a companion in collecting the material and knowledge that became the background for this volume. He has earned the respect and admiration of many through dedicated effort as a public servant, hard work, and by his life as a devoted family man. His collections have supported my historical venture with a generosity and openness second to none. Bob, now serving his third term as mayor of Atlantic Highlands, enjoys widespread public admiration and esteem. I am pleased to add my personal admiration and respect through dedication of this book.

First published 1996
Re-issued 2003

Published by Arcadia Publishing
an imprint of Tempus Publishing Inc.
Charleston SC, Chicago, Portsmouth NH,
San Francisco

Printed in Great Britain

Library of Congress Catalog Card Number: 2003106979

For all general information contact Arcadia Publishing at:
Telephone 843-853-2070
Fax 843-853-0044
E-mail sales@arcadiapublishing.com
For customer service and orders:
Toll-Free 1-888-313-2665

Visit us on the internet at http://www.arcadiapublishing.com

Contents

A Measure of Difference

Atlantic Highlands has always taken pride in being distinct from its surroundings. Conceived as the idea of one man, Thomas Henry Leonard, it was founded as a Methodist camp meeting grounds. Leonard tells the story of his plan to divide part of his farm into lots in his *From Indian Trail to Electric Rail* (Atlantic Highlands: The *Atlantic Highlands Journal*, 1923; reprinted by the Atlantic Highlands Historical Society). He realized that transporting visitors to the shore was fundamental to the area's growth, and in 1878 he organized the Bay View Transportation Company.

The company's original facilities were less than adequate, but fortunately one of the early visitors included Reverend James E. Lake. Lake saw the area's potential and convinced church leaders to form the Atlantic Highlands Association for the establishment of a resort. Their action led to a church vs. state contest on February 11, 1881. The Reverend Lake secured in his name nearly 400 acres of farmland belonging to Edward Hooper, Thomas Leonard, John L. Patterson, Charles H. Woodward, and Nathaniel Roberts. He also became president of the Association. Its Methodist control was assured by a constitution establishing a twelve-member board of directors, requiring that four be Methodist ministers and four be either Methodist ministers or lay members. Paid-in capital was a meager $10,000, while the Association carried a large debt. The first sale of lots by auction took place on June 1, 1881. Methodist clergy were prominent among the buyers at the sale, which raised $30,075.

The Association purchased the first Atlantic Heights pier and extended it 1,350 feet into the bay. The proximity to New York City was an important factor in the site selection, and reliable docking facilities which were not dependent on favorable tides were critical to the locale. Plans for civic improvements were ambitious and early real estate activity vigorous. Optimism prevailed, particularly among the real estate-owning directors, who declared a dividend payable in lots. The result was a steep decline in the Association's stock and a loss of confidence in the promoters, who appeared more interested in their investments than the betterment of the community. Business activity declined, despite a railroad connection made in 1883 and the opening of impressive recreational facilities. Reverend Lake and his secretary, Somers T. Champion (also his brother-in-law), were forced to resign. Reverend Dr. E.C.

Curtis was elected president and proceeded to reduce the Association's debt by the sale of lots. Although his sales campaign progressed, public improvements, particularly street lighting and road conditions, lagged. The public moved toward assuming greater control of affairs through the formation of a borough. Two young women journalists spurred public opinion in favor of its establishment, Ella S. Leonard and Caroline G. Lingle, publishers of the *Atlantic Highlands Independent*.

It was a simple matter for a small area to organize a borough in the 1880s. Although the 1844 New Jersey Constitution required an act of the legislature to create a new municipality, an 1878 act permitted areas of no more than 4 square miles with a population of no more than 5,500 to seek a referendum for establishing a borough, through a petition signed by the owners of at least 10 percent of the value of assessed property within its proposed borders. Borough authority was limited, but the borough could raise minor taxes for local improvements. There were two sources of opposition: some voters did not want the burden of an additional tax, and the Association was strongly opposed to this challenge of its authority.

Voters chose in favor organizing the borough on March 7, 1887. The Association took legal action, claiming that the legislature conferred upon their corporate body various municipal powers, and that the Association could not be subject to rule by a municipal corporation. The borough prevailed, obtaining the support of the populace, largely through the careful expenditure of nearly $500 the first year, which produced meaningful improvements in road and street lighting conditions.

The name of the new municipality was a source of debate. The area had been known as Bay View, which was rejected due to its close association with Leonard's development and its usage in an area larger than the new borough's borders. Atlantic Highlands was eventually chosen, despite critic's objections that the name was tied to the Association and that the early settlement was not in the highlands or on the Atlantic.

The town prospered and became the business center for surrounding parts of Middletown Township. Some of the borough's progress can be traced through promotional material issued by various interests. Two are picture sources for this work: the Atlantic Highlands Board of Trade's 1892 publication *Atlantic Highlands*, and Thomas J. Emery's *Souvenir Cottage List of 1899*, a virtual pictorial guide to the town. References herein to "Leonard" and the "Emery booklet" refer to these two works.

A Word on Pictures and Organization

Each author of a pictorial history has the challenge of seeking historical balance under the constraints of available illustrations. The response to the inevitable question of why a particular subject was omitted is often an admission of a lack of a desired image. In addition, one purpose of an Images of America work is the reflection of the spirit and imagery of the past, thereby embracing subject matter which is not necessarily the substance of major historical impact. Thus, a major site or figure may be omitted, while unidentified people or ordinary business scenes are included. The choice of five chapters was made to present four major topics of historical significance to the growth of the town, with one catch-all chapter to embrace all else, titled "People, Places, and Events."

The ease of travel to Atlantic Highlands was a basic issue in its development and growth, the reason for beginning with "Transportation." The "Harbor and Shore" provided the initial lure for visitors and early residents. The harbor was also critical to remaking the town's image after World War II, when commercial activity changed its character. "First Avenue" long

was, and still is, a key measure of the town's activity and prosperity. The pictures trace much of that thoroughfare's transformation, albeit with gaps. "Hotels and Houses" are an unusual linkage, joined as early visitors became settlers by moving from the former to the latter. Review of early housing patterns revealed a practice requiring more extensive study: rental housing as a major commercial activity.

The publication of this type of work invariably results in the surfacing of publishable pictures from owners willing to lend them, "if only I had known." The completion of this book left the author with a notable number of unused pictures. A second volume is planned, but more pictures are needed. I would appreciate hearing from picture owners who are willing to permit the making of copy prints for the next work. Please write to me at 71 Fish Hawk Drive, Middletown, New Jersey 07748, or call me at (908) 671-2645.

Acknowledgments

My deepest thanks and gratitude to all who lent the material that made this book. I wish to extend special thanks and appreciation to Helen Marchetti and the Atlantic Highlands Historical Society, for access to their collections, the gesture that was the starting point for this project; to those who entrusted me with family heirlooms, who have earned the personal pride of portraying their ancestors as part of Atlantic Highlands' history, including Norman and Spencer Samuelsen, June Mount Walling, and George and Alma Wuesthoff; and to Michael and Mary Cassone and Robert A. Schoeffling (for whom a personal word is on p. 4), as the private collectors with the greatest number of contributions.

Thanks and appreciation to all, whether their contributions have been a single or many pictures. You have earned stature as the co-producers of this volume: the Atlantic Highlands Fire Department, Edwin F. Banfield, Olga Boeckel, Joseph Carney, the Honorable Lawrence A. Carton Jr., Maryann and Modesto Caso, Elizabeth McCullough, Mo Cuocci, Leonard Edwards, Alexander Finch, James P. Fleming, Lawrence G. Fobes, George McCallum, Kathleen McGrath, Gardiner Marek, Photography Unlimited by Dorn's, the late John M. Pillsbury, Posten's Funeral Home, John Rhody, John Rieth, Karen L. Schnitzspahn, Joan Smith, and Michael Steinhorn.

And last, but not least, thanks to my dear wife, Barbara Ann, for her assistance with the manuscript.

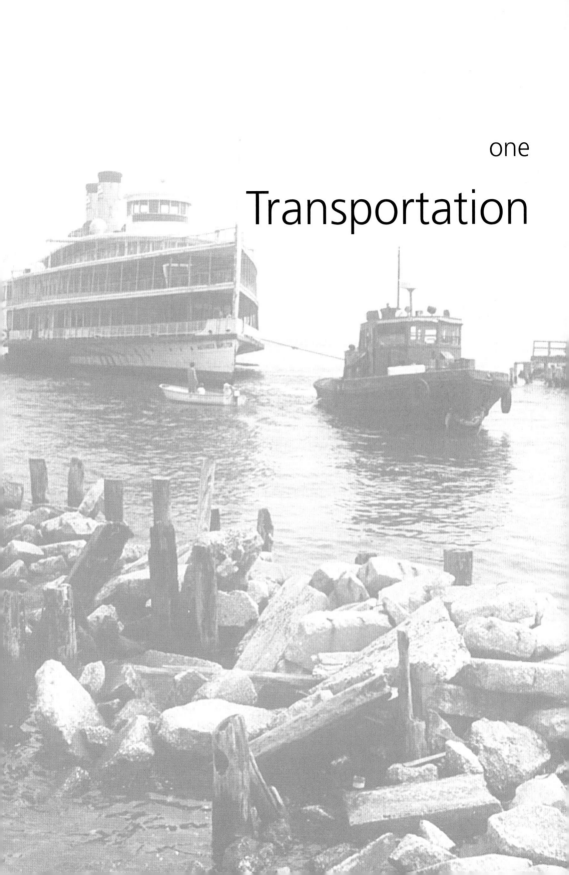

one

Transportation

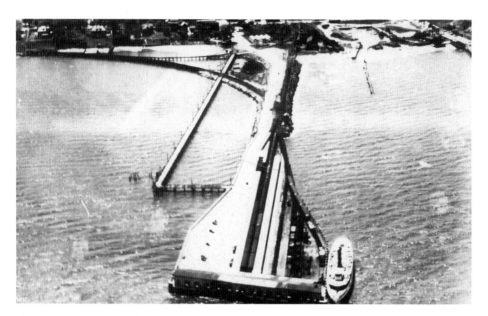

The earliest Atlantic Highlands pier was short and steamer travel was at times dependent on the tides. The federal government created an enormous opportunity for the town in 1891 by expelling the Central Railroad steamers from dockage on Sandy Hook, effective the next year. The pier was lengthened, opening on Memorial Day, 1892. A rail connection to Highlands was built so the railroad from this pier could continue the sea shore run down the Atlantic coast. The land around the dock, including the borough and surrounding parts of Middletown Township, saw enhanced real estate interest with the convenience of the improved travel facilities. This is a *c.* 1932 aerial view that merits comparison with the map on p. 2.

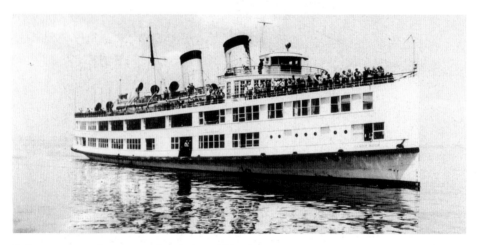

Early steamers on the New York-Atlantic Highlands route were smaller, slower vessels, including the *Thomas Collyer* and *Marion*. Two new ships in 1888 and 1889, the *Monmouth* and the *Sandy Hook* (shown here), established a new standard of speed and luxury. This image is from a *c.* 1930s postcard; the *Sandy Hook*'s maiden voyage on June 25, 1889, featured a boat quite different in appearance. Damaged in a 1931 fire, the *Sandy Hook* was remodeled with open observation and promenade decks, and with other decks enclosed by glass. Its new dining salon was decorated with large murals and sold souvenir plates. Its trial run was on May 17, 1932.

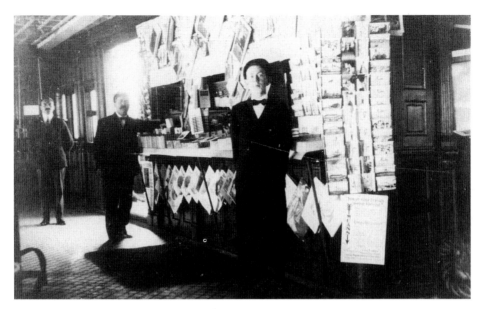

This picture shows a newsstand on the *Asbury Park c.* 1910. Remember Michaelangelo Antonioni's 1967 film *Blow-Up*? Wouldn't it be wonderful if someone became obsessed with these undated photographs picturing publications and enlarged them until the dates showed?

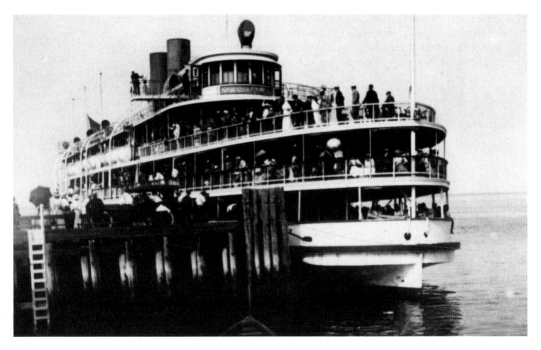

The *Mandalay* was built in 1889 by the Harlan and Hollingsworth Co., Inc., of Wilmington, Delaware, as the Pennsylvania Railroad automobile ferry "Express." This 272-foot-long, iron-hulled, oil-burning steamer was rebuilt to plans by Frank E. Kirby after a *c.* 1913 fire. The *Mandalay* ran the Battery, New York City route to the Avenue A, Atlantic Highlands dock from 1917 to her loss in 1938. (With thanks to the Honorable Theodore J. Labrecque.)

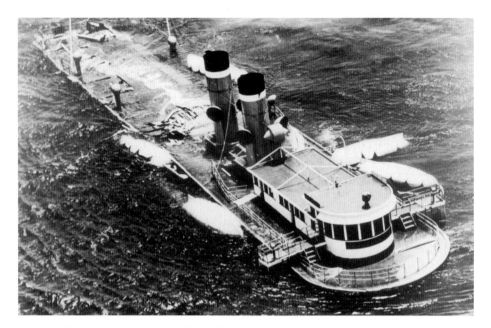

The *Mandalay* sank May 28, 1938, after colliding with the Eastern Steamship Lines vessel SS *Acadia* in New York Harbor just below the Narrows. Captain Philip R. Curran was master. All 325 persons on board were saved. The *Mandalay* was the principal transport for city visitors to the Atlantic Beach Amusement Park. Its loss dimmed the future of the struggling park. (Collection of the Atlantic Highlands Historical Society.)

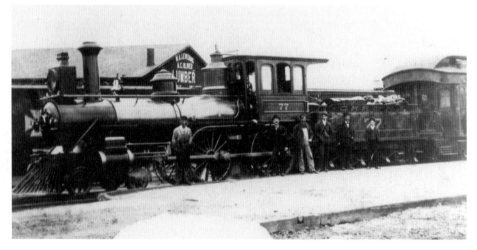

The first Atlantic Highlands railroad station was one block west of First Avenue, from Highland to Mount Avenues. This photograph of Central Railroad of New Jersey #77, the Penobscot, built by the Baldwin Locomotive Works, was taken in conjunction with the opening of the long pier on May 30, 1889. The station was later used for freight. The building in the background is in A. Levering and A. C. Oliver's Lumber Yard. A later generation may recall Atlantic Supply Co. there. Posing are: Robert Flett (fireman), William Mooney (engineer), "Al" Miles (baggage master), William Stickles (assistant freight agent), Charles R. Snedeker (foreman), and Ellis Parker (clerk and messenger). (Collection of Ed Banfield.)

Above: A new railroad station, designed by Frank Bodine and built by C.W. Kafer of Trenton, was erected in 1893 about 150 feet west of the Homestead Block. The site, now a parking lot, had been the local public horse sheds. Their demolition caused travelers inconvenience. By 1895 forty-two trains were arriving and departing daily. The station also housed telegraph and express facilities. It was destroyed by fire on December 16, 1951. (Collection of Ed Banfield.)

Below right: The rise in the elevation of Bay View Avenue, now Ocean Boulevard, is reflected in the descent needed to reach the station. The Sea View Hotel was a short distance to the east, readily walkable if your baggage was carried. This *c.* 1908 postcard shows the avenue's elevation and the proximity to the row of houses still lining the western stem of Ocean Boulevard. (Collection of John Rhody.)

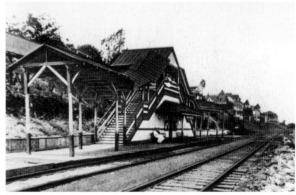

Left: The Bay View Avenue railroad station was a two-minute stop from the pier. This lane, about 150 feet east of Bath Avenue, led to the stairway descending to the tracks at shore level. (Collection of the Atlantic Highlands Historical Society.)

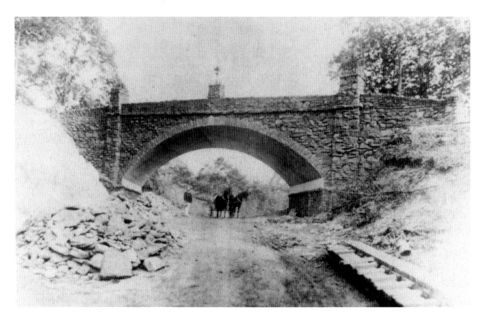

A wooden bridge on Mount Avenue crossing Grand Avenue was regarded as neither safe nor attractive in the 1890s. It was built when the Grand Avenue summit was cut down by the Atlantic Highlands Association. George F. Lawrie, of Observatory Park, not only advocated a substantial replacement, but also drew plans with a Miss Waldron, according to the *Monmouth Press* of November 23, 1895. The structure was described as a "rustic stone, Milan arch concrete and steel bridge with a span of fifty feet and placed at an angle of fifty-three degrees over Grand Avenue." This construction photograph is dated 1896.

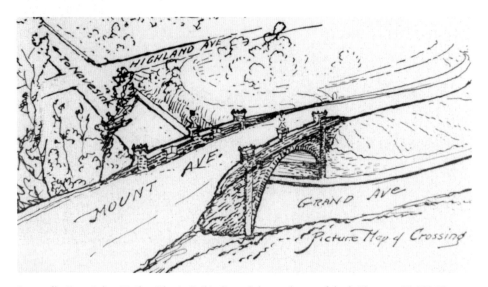

Leonard's *From Indian Trail to Electric Rail* indicated the total cost of the bridge was $3,532.89. The volume also contained this diagram, illustrating the spanning of Grand Avenue. Lawrie said at the dedication that the bridge would do for centuries, perhaps. Well, it would not, as built. The Monmouth County Division of Engineering oversaw the bridge's total reconstruction in 1993–94, winning an award for the faithfulness of its restoration.

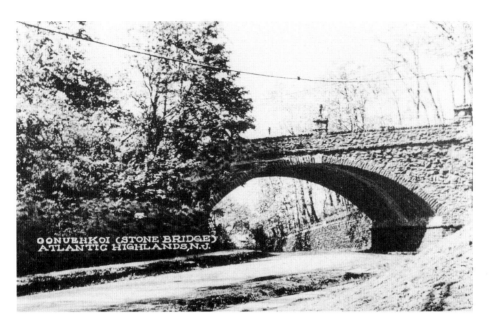

The borough was willing to contribute the cost of a wooden bridge, about $500, with the balance of a projected near $3,000 total to be paid by private subscription. Lawrie was the largest contributor. Public improvement was his motivation, as Lawrie did not even use the bridge to drive to his nearby property. This view from a *c.* 1940 postcard in the collection of the Atlantic Highlands Historical Society, looks north on Grand Avenue, a scene virtually unchanged today.

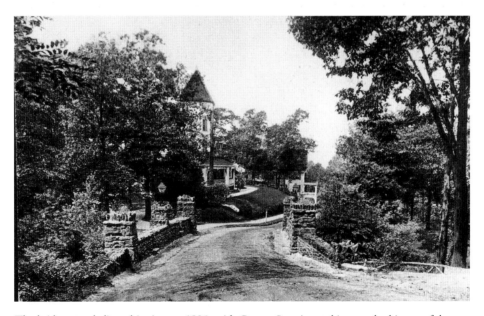

The bridge was dedicated in August 1896, with George Lawrie speaking on the history of the bridge project and praising the contractor, Nimrod Woodward. Lawrie asked permission of the mayor and council to name the bridge Oononnekoi, commemorating an Indian tribe that was once claimed to be in the area. Many spelling variations have been noted. This postcard view is *c.* 1910. (Collection of the Atlantic Highlands Historical Society.)

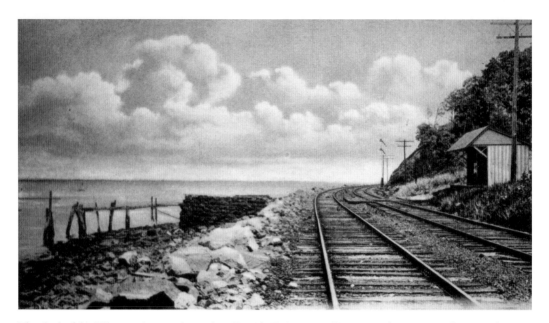

The shed of the Hilton station was located on Bayside Drive, east of Eyrie Road. Houses in the way of the new line were moved during construction in 1889.

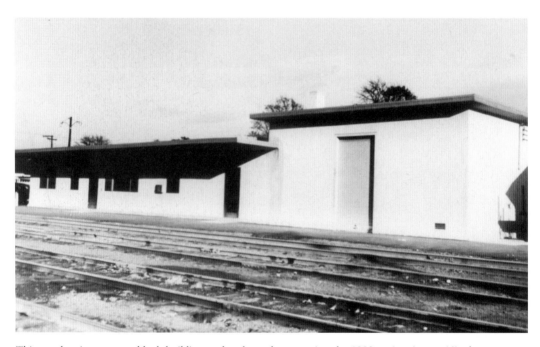

This nondescript concrete block building replaced, on the same site, the 1893 station (see p. 12), the year after the latter's 1951 fire. It handled both passenger and freight traffic. The station was demolished in 1973, two years after freight service was discontinued in 1971.

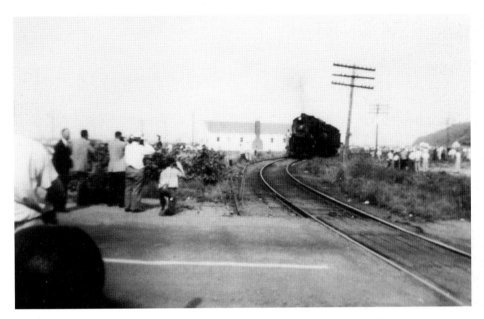

Alec Finch was present on July 11, 1954, for the fan trip of the North Jersey Chapter of the National Railway Historical Society. The train was pulled by the last steam locomotive in regular service of the Central Railroad of New Jersey. The trip originated in Jersey City and traveled to Freehold, Bay Head, and along the shore before its return. Note the senior citizens' building in the background, an aid for envisioning the site.

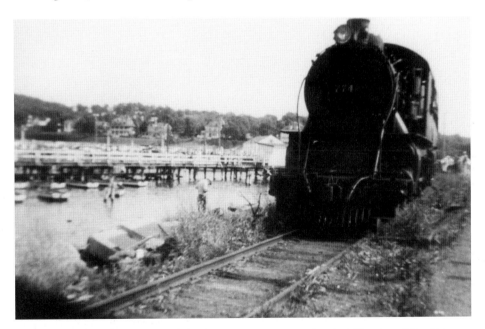

Engine #774 had one more public exposure, an appearance in the 1955 film about West Point, *The Long Gray Line*. Although rail preservationists would have liked the locomotive to have been saved, #774's water tubes needed replacement, a superfluous expense for a bankrupt line. Thus, it was scrapped. This view is at the "Y" that facilitated a train's changing direction.

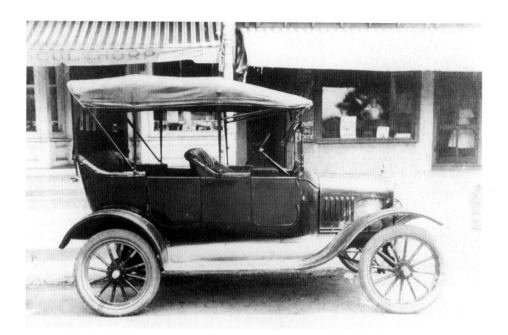

This picture, from the collection of the Atlantic Highlands Historical Society, is labeled "Daddy's First Car." "Daddy" was Cyrenus Stryker, while the vehicle is a Model T Ford. The locale is the east side of First Avenue, outside Stanley Sculthorp's real estate and insurance office at 114 First. A poster in the window advertising the Jack Dempsey vs. Georges Carpantier heavyweight championship fight suggests the picture dates shortly before that July 2, 1921 event.

James A. Sage ran an express, boarding, and livery facility at the northwest corner of Mount and Second Avenues. This view is from the 1904 *Norton's Directory*. His ad also offered a variety of new and used wagons for sale, horses for hire, and the service of sending furniture wagons to the city for transporting goods to town.

Simon Lake spent a long career advancing the cause of submarines. Although history has recorded John Holland as the developer of the first practical submarine, Lake made many important contributions and innovations. He was born in Pleasantville, New Jersey, on September 4, 1866, and spent his early business years in Atlantic Highlands, where he was aided financially by his uncle and aunt, Mr. and Mrs. Somers T. Champion. Town contractor Hugh Warden built the early experimental vessel *Argonaut Jr.* in Atlantic Highlands. Lake organized several submarine building companies, the first of them, the Lake Submarine Company, at Atlantic Highlands in 1895. Operations moved to Connecticut in 1900. Since rival Holland had the business of the U.S. Navy, Lake spent much effort to sell his submarine to overseas governments, including Germany and Japan. He died in 1945. (From Lake's 1918 *The Submarine In War And Peace*.)

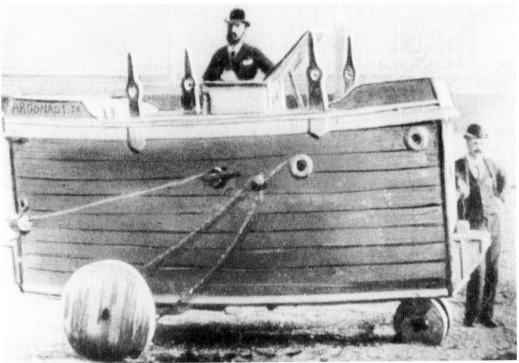

Lake built the *Argonaut Jr.* (shown here) in 1894. In his 1918 *The Submarine In War And Peace*, he describes the operation of the *Argonaut First*, which he conceived of prior to the *Argonaut Jr.* but which was built at a later date: "She was propelled when on the bottom by a man turning a crank on the inside. Our compressed-air reservoir was a soda-water fountain tank. The compressed-air pump was a plumber's hand-pump, by which means we were able to compress the air in the tanks to a pressure of about one hundred pounds per square inch." By 1904 the Japanese were eagerly seeking Lake's services and the original boat was abandoned on the Atlantic Highlands shore. Simon Lake Drive at the marina commemorates this naval pioneer's early work in town. (From Lake's 1918 *The Submarine In War And Peace*.)

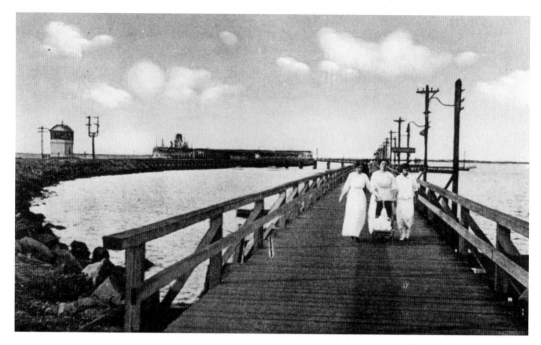

The boat landing was initially reached via this narrow boardwalk prior to its widening for automobiles (see p. 10). This view is from a *c.* 1915 postcard.

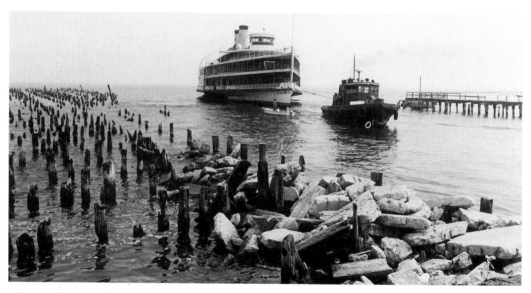

The former Hudson River Day Lines steamer *Alexander Hamilton* was towed into the Atlantic Highlands harbor in July 1975 with the owners' expectations of opening a floating restaurant. The 350-foot vessel had a long and distinguished career serving day-trippers on the Hudson River and earned a listing on the National Register of Historic Places. Environmental concerns thwarted the dockside dining plans. The ship was towed, with considerable difficulty, to a temporary mooring at the Navy pier at Leonardo, with plans for eventual relocation to upstate New York. The ship sank at its mooring in a storm on November 8, 1977.

two

Harbor and Shore

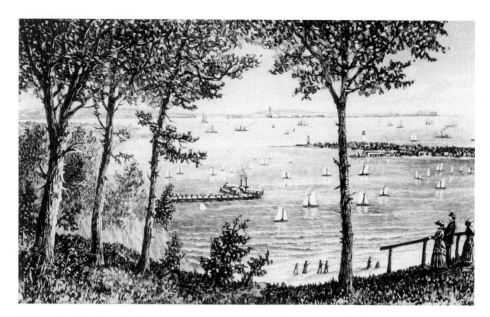

The scenic splendor of Atlantic Highlands, an appeal in its early development, continues to enthrall viewers today. The hills rise to the highest point on the mainland eastern seacoast, offering spectacular vistas of the surrounding harbors, the ocean, and Sandy Hook. This view from Point Lookout, the site of the house on the bottom of p. 66, was published in the 1882 First Annual Report of the Atlantic Highlands Association, in Thomas Henry Leonard's *From Indian Trail To Electric Rail*, and in numerous promotional works in between. Its effective capture of the feeling of scenic wonder merits additional exposure.

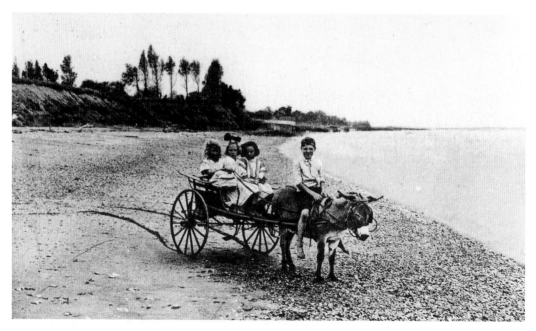

A donkey and cart provide simple amusement on an Atlantic Highlands beach. This picture comes from a *c.* 1910 postcard.

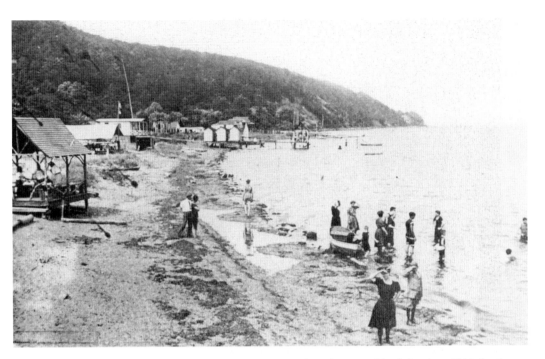

Tents, cabins, and bulky bathing costumes characterize the Atlantic Highlands beach, *c.* 1910. Storing tents for the winter was a key line of business for early warehouseman Calvin W. Miller (see p. 91). One wonders about the exact locale, but the July 1911 edition of the *Monmouth County Edition of American Suburbs* labeled it Atlantic Highlands.

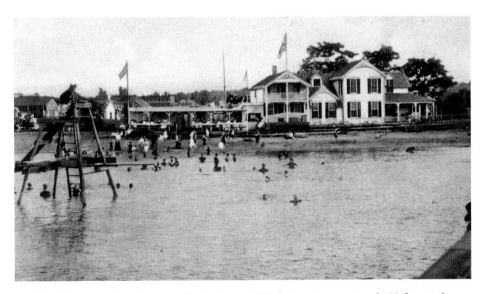

In 1891, John Leslie bought a lot with frontages of 225 feet on Avenue A and 400 feet on the bay. Leslies Beach was a recreational site for many years, later run by Frank, John's son. The property, including a 10-room house, 160 bathhouses, 2 bungalows, and refreshment stands, was sold in 1933 to Andrew Richards, at one time Atlantic Highlands' largest property owner. Here we see it as it appeared on a *c.* 1910 postcard.

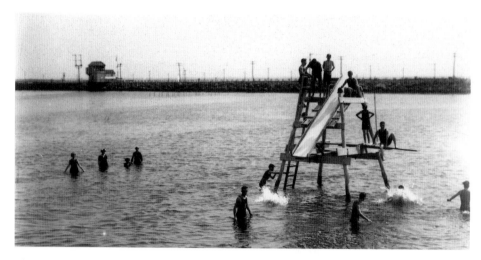

The water slide shown here is from a 1913 view taken by the shore's most famed photographers, the Pach Brothers. It is their only known view of Atlantic Highlands. Karen L. Schnitzspahn, owner of the glass plate and donor of the print, pointed out that it would have been unlikely for the Pachs to have taken only one photograph while in town. Thus, one wonders if there exists a cache of Pach Atlantic Highlands prints waiting to be uncovered.

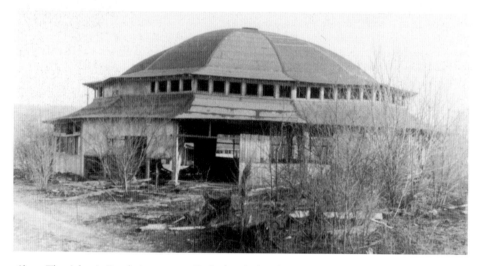

Above: The Atlantic Beach Amusement Park closed after the problem-plagued 1940 season. The property was sold to the Atlantic Investment Co. that December, one step ahead of borough tax foreclosure. Business had been declining for the last few years, the end hastened by the loss of the *Mandalay* (see p. 11) in 1938, which docked at the park and was considered an integral part of its operation. The carousel was reportedly sold to the city of Philadelphia for re-erection in a park on the banks of the Delaware. Its enclosure stood in ruin for years. The park site is a marina today.

Opposite bottom: The human interest at Atlantic Beach included the "Slide for Life," executed several times a day by Al Morton, the "Great Nervo"; a freak and animal show; an Indian village; and "Cesar the Great's Magic Show," performed by Cesar Devlin. Several Biograph Studio films had scenes set here. In addition, the sandy shore was the site for impromptu gatherings of "bathing beauties." Which one is your favorite?

The Atlantic Beach Amusement Park was built in 1915 on the shore of Sandy Hook Bay running from Avenue A to Avenue D, the site of the old Anthony J. Campbell homestead. The house was used by the park. Visitors were brought by New York steamers, the Central Railroad's Sandy Hook line, and the *Mandalay*. The latter sailed from the Battery in downtown Manhattan three times daily and was a particular favorite with park travelers. Despite twenty-five years of popular patronage, the only views known are from a single brochure in the collection of Maryann Caso, who kindly lent this and the following two images.

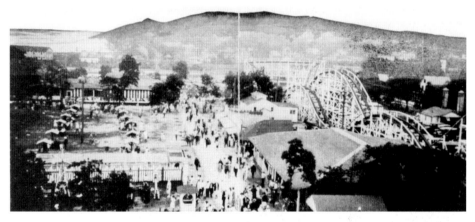

The roller coaster was considered one of the more daring rides on the coast. The merry-go-round, imported from Germany, was a particular favorite. Fires plagued the park, such as the one in December 1937 that destroyed the bumper car ride called "Dodg'em." (Why dodge? Wasn't bumping was the name of the game?) Organization-sponsored outings and picnics in the grove were popular. The park included an athletic field and bathing beach, with individual bathing houses to accommodate two thousand people. A miniature railway, Ferris Wheel, whip, airplane swings, and Custer car racers were among the other rides.

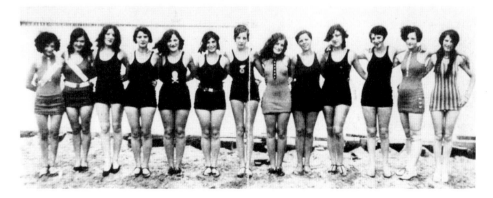

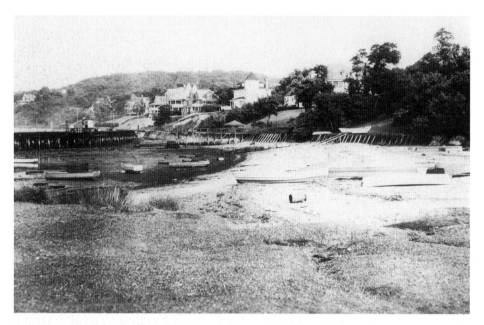

This *c.* 1910 view looking east reflects the proximity of the railroad to the shore and the row of houses rising up Ocean Boulevard from its foot at First Avenue.

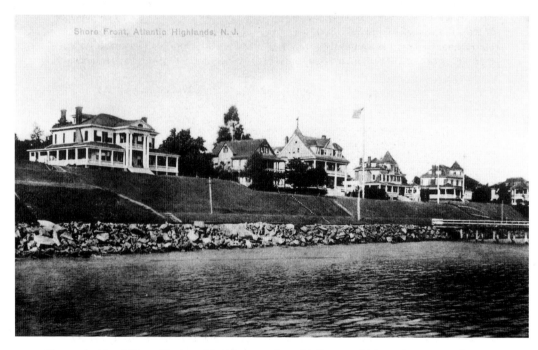

Shore Front, Atlantic Highlands, N. J.

The north side of Ocean Boulevard looking west from 54 Ocean, which can be seen on the bottom of p. 71. The Pavonia Yacht Club (see the top of p. 68), is behind the flagpole. Contrast the waterfront site with the landfill scene opposite. Despite the major benefit to the borough from the harbor, the contrast makes several shoreline property owners' lack of total enthusiasm for the project understandable. (Collection of the Atlantic Highlands Historical Society.)

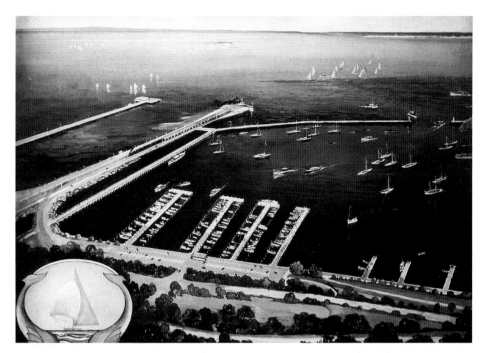

A breakwater and harbor had been discussed and desired in Atlantic Highlands since the late 1800s. The Pavonia Yacht Club may have first aired the issue when they opened their clubhouse in 1890. The plan of the project as built was not revealed until just prior to the start of construction. Compare the completed harbor with this rendering from 1938 by noted Atlantic Highlands artist Corwin K. Linson. An opening in the breakwater is the most notable difference.

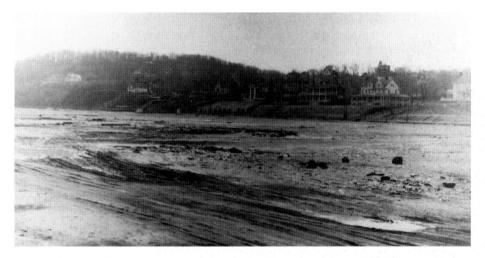

Defying the old real estate saw of "they aren't making any new land" are the fill-built acres created on the shore east of First Avenue. A protracted dispute with shore property owners arose over compensation for their riparian rights. They sued to seek greater sums than the borough's offer. The borough won the case in the circuit court at Freehold, with their modest offers reduced substantially, to $1 for most owners. An appeal increased the circuit court's figures, but not to the level of the borough's earlier offers.

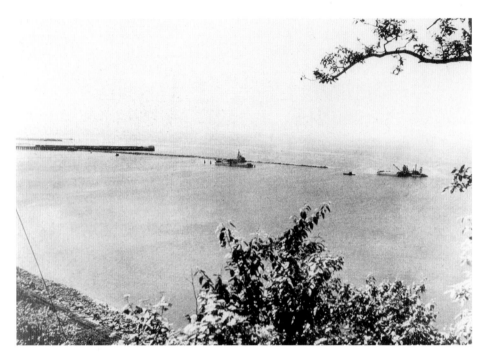

Construction of the breakwater preceded the building of the harbor, with work beginning in September 1939. Bids for the shore-side facilities were not awarded until the summer of 1940. (From the Summer 1940 edition of *Monmouth Pictorial*.)

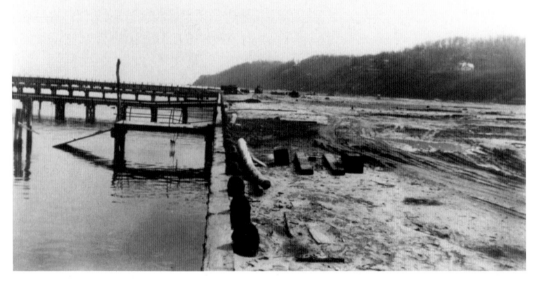

A second view of the landfill after construction of the docks began. A September 23, 1931 *Red Bank Register* headline, "Atlantic Highlands Harbor Plans Ready," topped an article outlining a project ready for implementation. Plans were drawn by Atlantic Highlands mechanical and civil engineer John Pinaud, who had earlier designed a lake harbor in Canada.

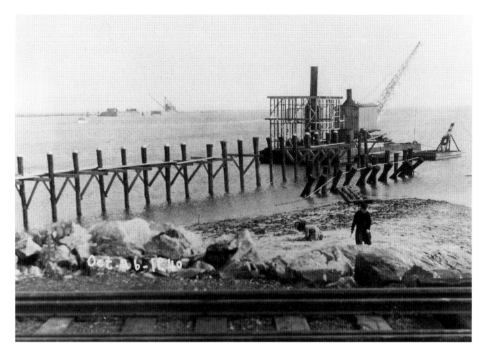

A construction view dated October 26, 1940. By 1931 the project was approved by the state board of commerce and navigation and by the war department. The state agreed to pay part of the cost, variously and modestly estimated between $60,000 and $75,000. When an ordinance for construction was introduced to the borough council, harbor advocates, led by a Lion's Club committee, expected proforma passage and a prompt start to the project.

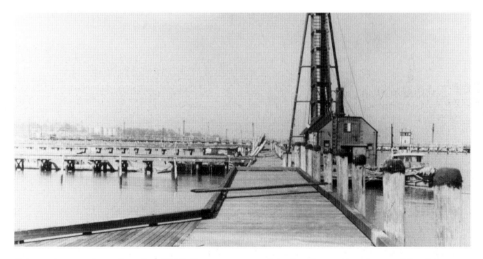

A later view, perhaps from late 1940. Press coverage of the breakwater hearings at Atlantic Highlands in January 1936 indicated that substantial evidence of need was required to effect the project. The harbor was envisioned as a refuge in storms for both commercial and pleasure craft. The endorsements of numerous mariners and the mayor of neighboring Highlands were obtained, with the harbor being advocated as not an exclusively local matter. The project's cost grew to about $135,000 with the addition of boat docks.

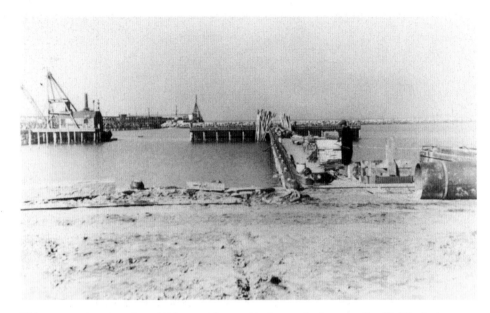

This construction scene is probably concurrent with that on the bottom of p. 29. The harbor was largely paid for by Public Works Administration funds. The total cost was over $900,000, close enough to the early promotional claim for "Atlantic Highlands' $1,000,000 Harbor," back in the days when a million was real money. The borough's share was $53,000 ($44,000 for construction and $9,000 for the acquisition of riparian rights).

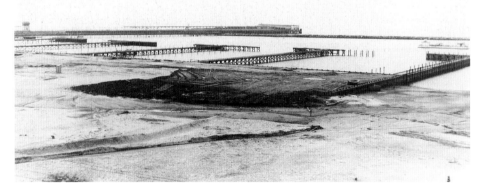

The harbor could not operate as a public facility during World War II and its business was slow in developing while the automotive and shipbuilding industries adjusted to peacetime conditions. Bonds needed to finance storm repairs were issued in 1945, 1946, and 1948 and were a drain on income. Revenue gradually increased until the harbor made a meaningful contribution to municipal finances. The history of the harbor is outlined in Earle Snyder's October 25, 1939 speech to the Sandy Hook Harbor Control Board (he was its chairman) printed in the November 2, 1939 *Red Bank Register* and the Atlantic Highlands Harbor Commission's 1958 annual report.

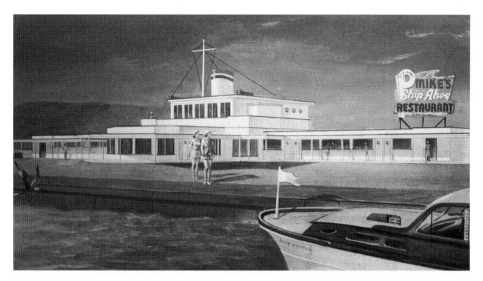

A rendering from a 1950s postcard of the harbor's administration building, designed by Rumson architect Robert E. Edwards and built in 1952. The public knows the building best as a restaurant, with the Shore Casino the present long-term occupant. Michael Stellas was the first tenant, with an annual rent of $2,000 or 8 percent of gross receipts. The Harbor Commission noted in its 1958 report that: "Mr. Stellas has made considerable improvements to the facilities, including an extensive addition to the building."

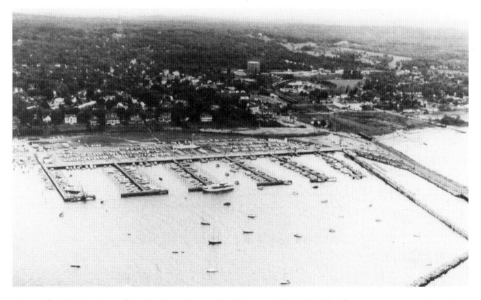

A *c.* early-1960s view of the harbor shows the absence of the Highlandia apartments at the juncture of First Avenue and Ocean Boulevard (above the one-story building in the parking lot). Train service at the pier had been discontinued, with the track used for lay-up purposes. The 1952 railroad station is a speck of white to the left of the trains. The Oscar Unz House, with its distinctive white columns at left, provides a point of reference for comparison with the image on the bottom of p. 26. The harbor administration building can be seen in the center of the parking lot.

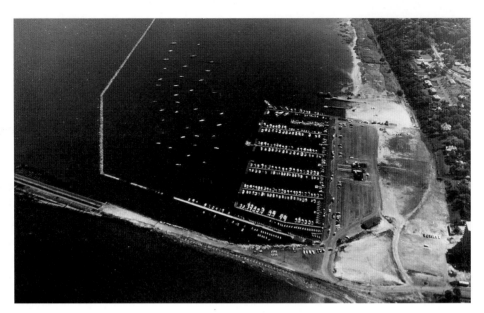

This *c.* 1970 view illustrates the roadbed of the abandoned railroad. The senior citizens' building marked the end of the paved section of the harbor parking lot then. It can be used as a point of reference for the railroad pictures on p. 17. The Highlandia apartments, barely visible at lower right, mark the start of Ocean Boulevard.

A late 1950s postcard of the public launch at the harbor amazes the landlubber author after numerous viewings. Imagine, driving one's car into the water! At first glance, the author thought there was sentimental value in the Pontiac at left, but, alas, closer examination reveals it as a 1954, not the 1953 in which he learned to drive. How about that De Soto up front, just like Cosmo's car, ridiculed regularly in the cartoon *Shoe*. Apparently getting wet are a Hudson (left) and a Frazer (right), two more names out of automotive memory lane.

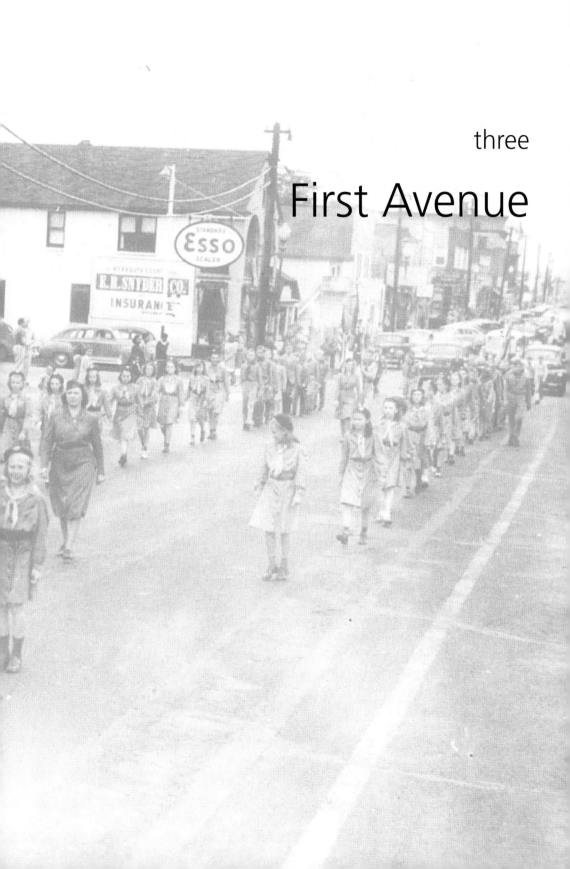

three

First Avenue

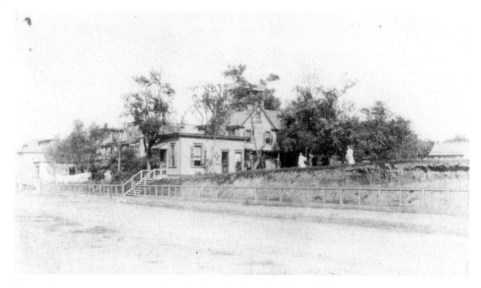

First Avenue was a narrow, sandy path when the farm buildings of Thomas Henry Leonard represented the only structures in the area prior to the founding of the town. Leonard decided to lay-out part of his farm in building lots after the successful 1879 summer season, starting with about 20 acres. Ezra A. Osborn mapped that land during the fall, on what became the east side of First Avenue. The house was on the west side where it remained until being moved in 1895. This view is from 1894, well after First Avenue had been widened.

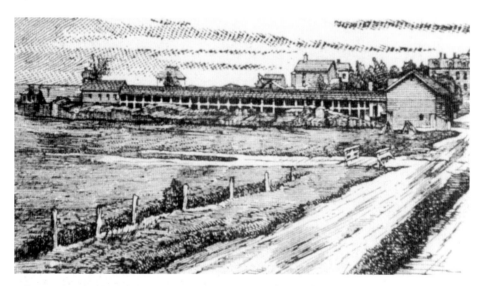

John J. Leonard and Thomas Henry Leonard joined as Leonard Bros., opening Atlantic Highlands' first lumberyard and hardware store in 1880, and continuing for ten years. Their yard was at the corner of First and Bay Avenues. Through a succession of consolidations, mergers, and new partners—including George McHenry (of Mickens and McHenry; successor to the Corning Lumber Company, another pioneer), James P. Hopping (who purchased the share of his partner Henry Ely), Edgar Cook, and others—the business became the long-established Hopping, McHenry and Frost. Their yard relocated to a block bounded by West, Lincoln, and Washington Avenues. This is a view of the first yard from the July 1888 *Atlantic Highlands Register*.

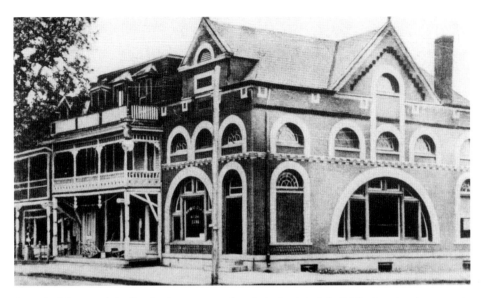

Several of the town's leading business persons founded a bank in July 1889, choosing the name Middletown Safe Deposit and Trust Co. Their plans changed promptly, and they organized instead as a national bank, opening for business September 17, 1889, in Peter J. Conover's store. The Atlantic Highlands National Bank erected their home at the southwest corner of First and Bay Avenues, occupying it in April 1890. One would like to see an early photograph of what both Leonard and a contemporary press account described as a one-story building. This postcard view is *c.* 1910. The bank was designed by Thomas J. Emery of Atlantic Highlands.

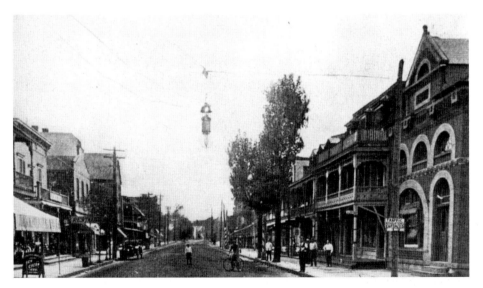

The Atlantic Highlands National Bank building dominated the block south of Bay Avenue. It has strong Romanesque elements, while the county's Historic Sites Inventory labeled it Victorian Gothic. Emery called it "modern American" in 1890. The store adjacent still stands, without its porches. The brick building behind the restaurant exists today at no. 42. The restaurant is likely Rohde's. A photographer in the middle of the street was as much an attention grabber around 1910 as one would be today.

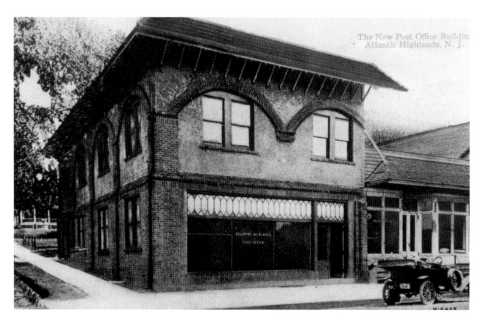

The post office building was built *c.* 1910 at the southeast corner of Ocean Boulevard and First Avenue. It housed the library on the second floor for some years prior to the 1970 opening of the present municipal complex, and is now occupied by a laundry. The adjacent store burned *c.* 1920s. That space is now a vacant lot.

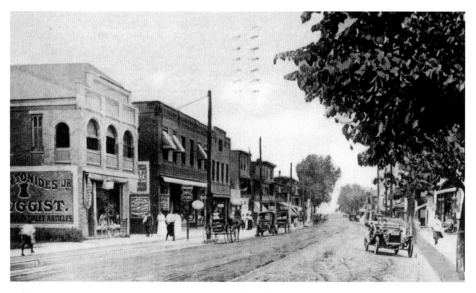

Thomas Henry Leonard's house, located on what became a block bordered by First, Mount, Railroad, and Center Avenues, was the origin of the name of the Homestead Block. It was a lengthy street, with an alley in the middle. Thomas J. Emery designed Ira Antonides' store and dwelling, built in 1905. The building stands with the alley closed by a yellow brick extension, which is not only compatible with the original, but aged to appear as uniform construction. The block has remained intact, and is shown here in a *c.* 1910 view looking north. (Collection of Michael Steinhorn.)

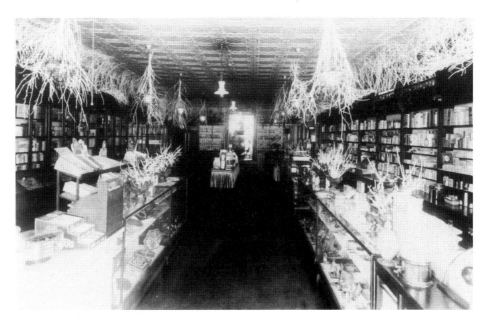

Ira Antonides learned the drug business with James Cooper Jr. of Red Bank. He began in Atlantic Highlands during the 1890s in partnership with Cooper, buying the latter's interest in 1903. The business grew and prospered, as reflected in this well-furnished and stocked interior from 1926. (Collection of the Atlantic Highlands Historical Society.)

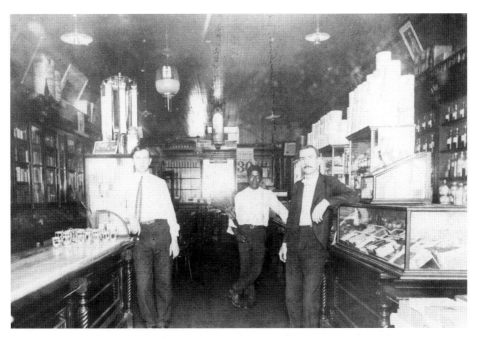

The place is Antonides' drug store. The day is Tuesday, August 30, with the year, perhaps 1921 or 1927. Note the well-stocked cigar case at right, the medicine bottles on the wall, and the expectation of soda traffic at left. Is the man at right the owner? Who else would wear a jacket on a pre-air-conditioning August day? (Collection of the Atlantic Highlands Historical Society.)

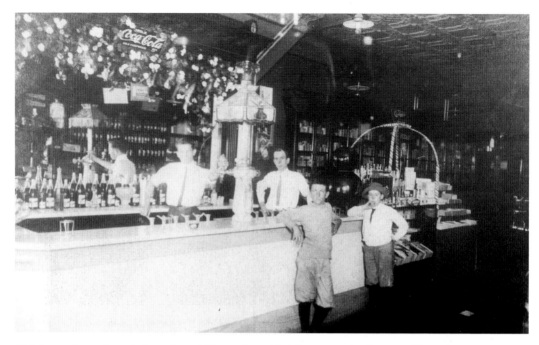

This image shows the soda fountain, *c.* 1920s, at Antonides' drug store. (Collection of the Atlantic Highlands Historical Society.)

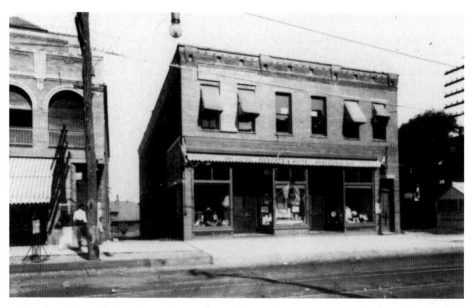

Fred A. White joined N.H. Roberts in his dry goods and grocery business in 1882. He and William M. Roberts bought the former Roberts' stock in 1889. They purchased this site on the Homestead Block from Thomas Henry Leonard and built the brick store *c.* 1902. The location today at 81 First Avenue is recognizable as the home of Presents on First and Shirley's Counting House. The decorative cornice has been removed and the storefronts built out to the building line *c.* 1970s. This is a *c.* 1915 picture from the Dorn's Collection.

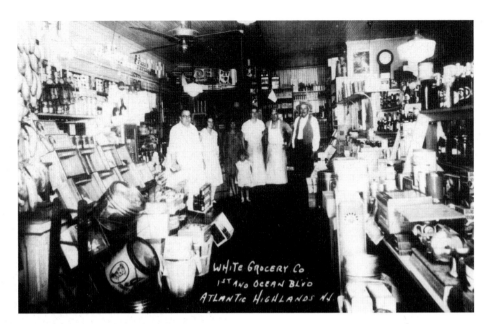

Fred A. White owned the White Grocery Co. in the late 1920s. His store was on the site of Highlandia's parking lot at First Avenue and Ocean Boulevard. Standing in the store are: Charles R. Mount Jr., Alma Layton Drinkwater, Jeane Mount, Joyce Mount, Matthew Murphy, Walter Anderson, and Charles R. Mount Sr. (Collection of the Atlantic Highlands Historical Society.)

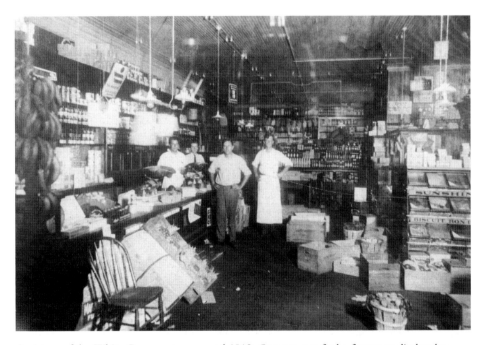

A picture of the White Grocery store around 1912. One can not find a fixture or display the same as on the bottom of the preceding page. The men are Charles Mount, Maynard Card, unknown, and Ashley Roop (who donated the picture to the Atlantic Highlands Historical Society).

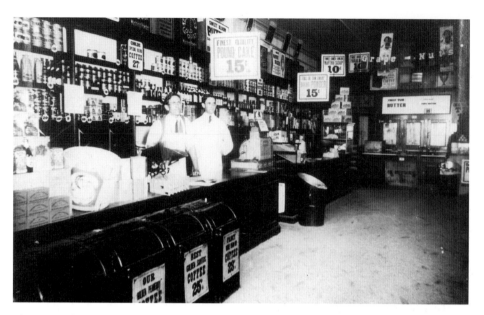

This image shows the "First Avenue Grocer," although it is not apparent if that is a person or location. The careful shopper had a choice of four blends of coffee at 23, 25, 27, and 28¢ per pound. One sees few brand names still current today in pictures over sixty years old, so it is pleasing to see Grape-Nuts hung across the rear of the store. The staff is unidentified. (Collection of the Atlantic Highlands Historical Society.)

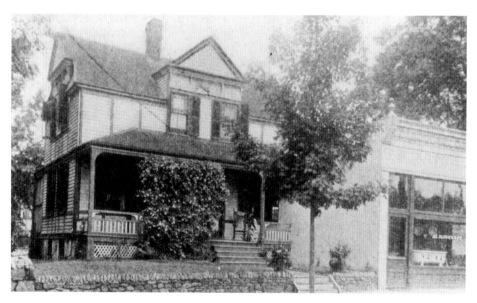

The house on First Avenue, near the northwest corner with Highland, was built *c.* 1887 for Thomas J. Roberts by John Geary. It had several tenants until purchased by John S. Flittcroft in the early years of this century, who conducted a plumbing shop in the building north of the house. The place was moved to Highland Avenue in 1930 when a new building was erected for the Jersey Central Power & Light Co. This picture is from the June 1904 edition of *The Industrial Recorder.*

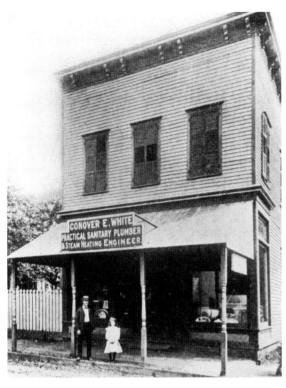

Left: Conover E. White's plumbing shop was at the northeast corner of First and Highland Avenues. He established the shop *c.* 1899, having come from his native Elberon to work for John Mulligan. White was long active in civic affairs, serving as a fireman and for three years as president of the borough's board of health. Later, White was also a master electrician. He died in 1938. The picture, subjects unknown, is from the June 1904 edition of *The Industrial Recorder.*

Below: The extensive stock of W.H. Posten's general store at 92–4 First Avenue is well-described by the facade and his ad in George Stout's 1895 *Atlantic Highlands Directory.*

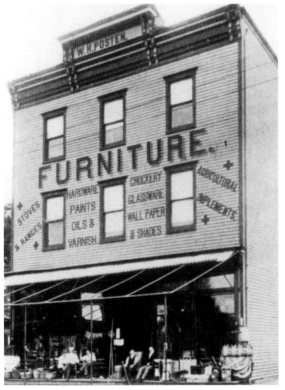

HARDWARE
AT
W. H. POSTEN'S, JR.

COLDWELL'S STANDARD

HARDWARE,
HOUSE FURNISHING GOODS
Of Every Description.

Paints and Oils,
WALL PAPER,

GLASS,
Cordage,
Tinware,
Pumps,

C r o c k e r Y
WOODENWARE, ETC.

NEW STORE,
NEW GOODS,

AND THE SAME POPULAR PRICES.

FIRST AVENUE, ATLANTIC HIGHLANDS

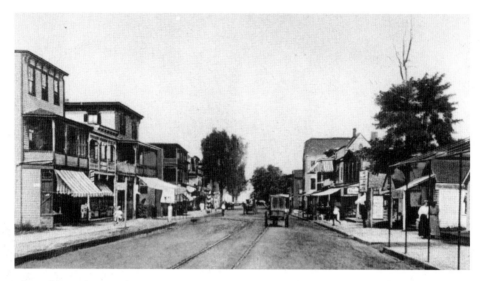

The trolley tracks turned west at Center Avenue, forming a loop to return to First Avenue. Several views of the block north of Center follow. (Collection of the Atlantic Highlands Historical Society.)

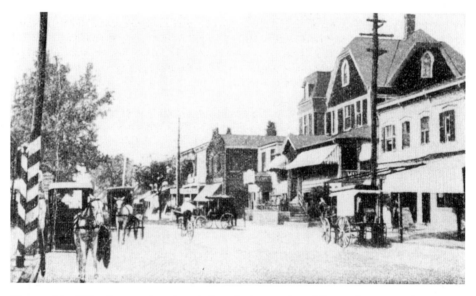

The east side of First Avenue viewed north from the intersection of Center Avenue on the west side is dominated by the Columbus Hotel, the building with the jerkinhead gables on the front and south sides. The brick building beyond is now the Harborside Grill. This picture is from the July 1911 Monmouth County edition of *American Suburbs*. A view from the opposite direction is at the bottom of p. 35.

Opposite below: First Avenue looking north from Center Avenue. This view is similar to that opposite. When the photographer is positioned closer to the middle of the street, he can câpture both sides. This is from a *c*. 1910 postcard.

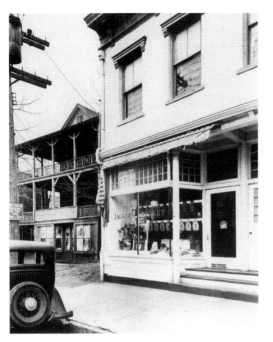 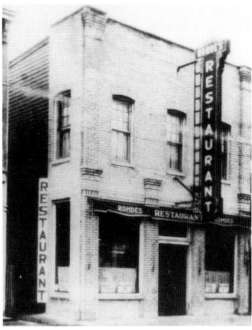

Above left: Jagger's Market long occupied 92 First Avenue. William Jagger entered the meat business *c.* 1901, coming to Atlantic Highlands *c.* 1913. He and John Pillsbury bought the building in 1931. John was a teen-age deliverer of meat for Jagger, an early commercial activity that was a prelude to his legal education, later stature at the bar, and reputation as one of Atlantic Highlands' greatest successes. (Collection of Atlantic Highlands Historical Society.)

Above right: Jacob Rodhe came to Atlantic Highlands in the 1880s and opened a restaurant with a name whose appeal lasted through a succession of later owners. This location is 40 First Avenue, with a brick face placed over a frame building. It was later the Pier Hotel and the Harborside Grill. The brick face has been replaced, while the pillasters and sides of the building have been stuccoed. The site is recognizable, adjacent to the Harborside Inn. (Collection of the Atlantic Highlands Historical Society.)

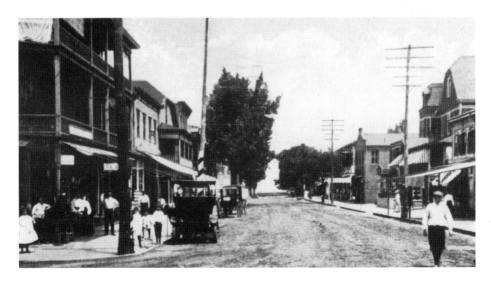

William Nesbit Snedeker founded a garage and automobile salesroom *c.* 1904. Snedeker was crippled from an 1893 railroad accident when his back was broken in a coupling mishap. He married a nurse he met in a subsequent hospital stay. Snedeker died in 1915 at about age forty-four. This view is *c.* 1920. The building was remodeled as the Atlantic Theater in 1921. (Collection of the Atlantic Highlands Historical Society.)

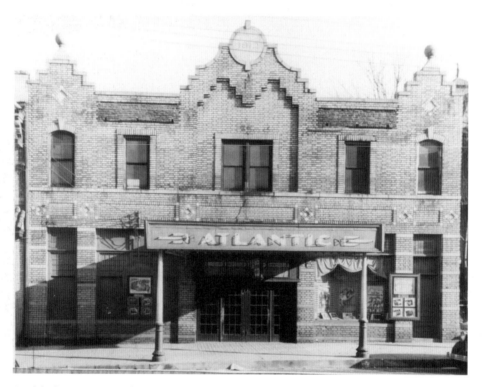

Snedeker's Garage, now the Atlantic Theater, was built in 1912. The artistic stepped-gable and decorative brickwork made this building, in its day, the most attractive on First Avenue. The 1921 theater remodeling left the structure's integrity intact. This view, lent by Len Edwards of the Atlantic Theater, is dated 1946, as indicated by the film *Nobody Lives Forever*. The next year brought a devastating facade remodeling, ameliorated by some pleasant Moderne decoration, attached a decade behind its time. See it in Volume II.

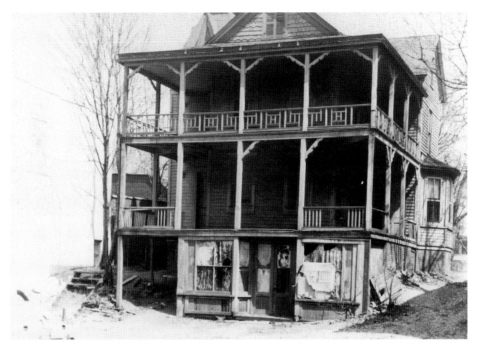

Could the porches on the Thomas Jennings House actually have been this unattractive, or is it a matter of the camera angle? Jennings, born in London, was a painting/decorating contractor and the first chief of the Atlantic Highlands Fire Department. Details of the origin and removal of the house are unclear; the site is now the vacant lot adjacent to the Atlantic Theater. (Collection of the Atlantic Highlands Historical Society.)

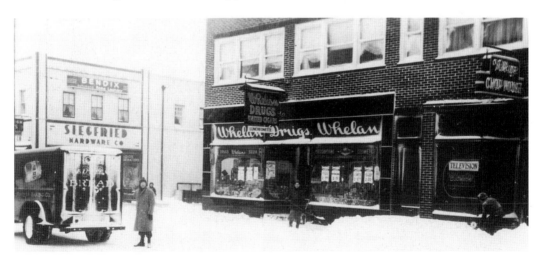

Benjamin G. Martin erected this building in 1930, on the site of the T.J. Roberts house on the northwest corner of First and Highland Avenues, as a showroom for Jersey Central Power & Light Co. The tenancy had changed by the time this photograph was taken during the December 1947 blizzard. Frank Siegfried built the hardware store on the southwest corner in 1940 on the foundation of the old Masonic hall, which was destroyed by fire on July 9, 1938. The bread truck is Fischer's. Note the sign "Television" in the window of the Village Chop House. It was a big deal in 1947.

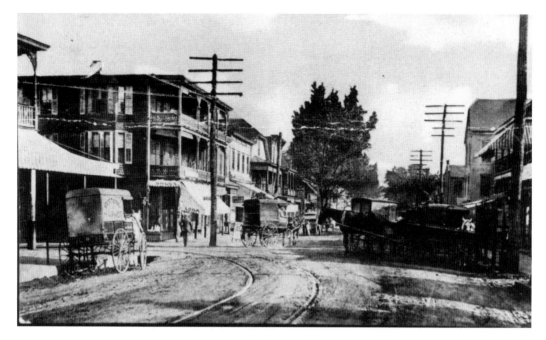

It was a busy market day on First Avenue looking north around 1910 at Center Avenue. The two three-story Morrell buildings on the corner date from the 1890s, while Thomas J. Roberts' store adjoins them. The corner, showing the trolley loop proceeding west, was one of the most frequently photographed, with a few-step repositioning of the camera creating a different impression.

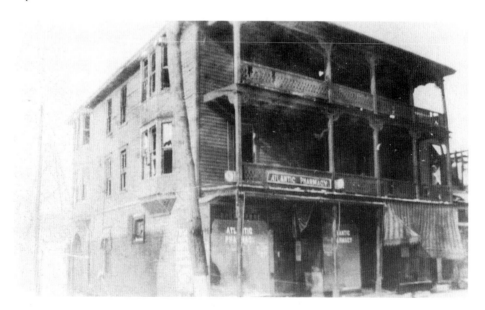

A fire, beginning in the basement of the Atlantic Pharmacy, destroyed William Morrell's buildings and the adjoining T.J. Roberts' building on December 27, 1917. A cold night and extensive streams of water that later froze hampered the fire-fighting effort and delayed the run of the trolley the next morning. Several families were made homeless.

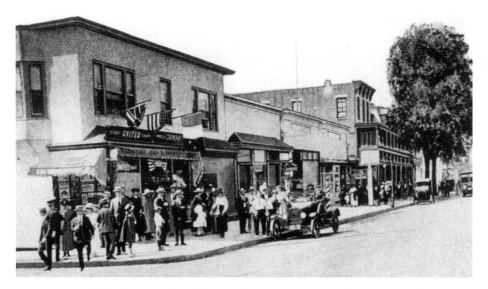

Lower, stucco-clad buildings replaced the burned structures at the northwest corner of First and Center Avenues. Bill Leff was a long-time owner of the United Cigar store on the corner. This early 1920s postcard reflects the beginnings of a modern look for the block.

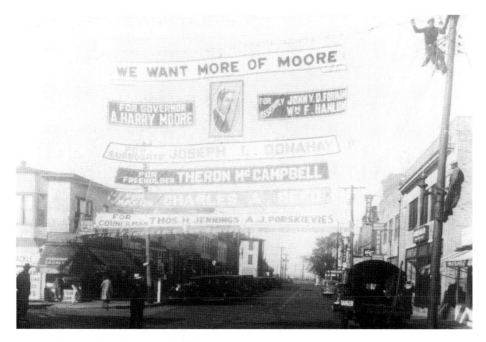

New Jersey received three more years of Moore (and his boss Frank Hague) after his 1937 defeat of Lester Clee. The Democrat Moore served three terms, also winning in 1925 and 1931. Under the 1844 constitution, a governor could not succeed himself, so Republicans Larson and Hoffman won the 1928 and 1934 elections between Moore's earlier victories. Theron McCampbell earlier served in the state assembly, but lost most of his electoral bids. The view is north at Center Avenue. Roy De Palma of the Jersey Central Power & Light Co. waves from the pole while longtime former mayor John Snedeker crosses the street.

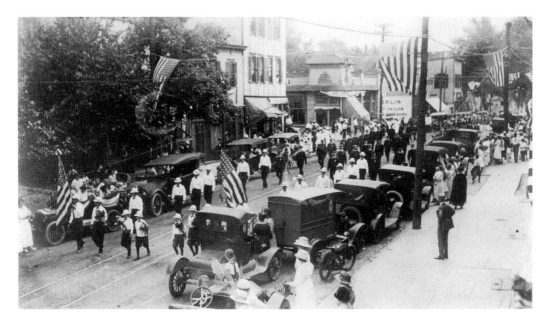

Atlantic Highlands held a welcome home celebration for its soldiers and sailors on August 21, 1919. Events included a parade, shown here on First Avenue, a late-afternoon dinner, and an entertainment festival at the storefront amusement park which included patriotic tableaux, dancing, a band concert, and fireworks.

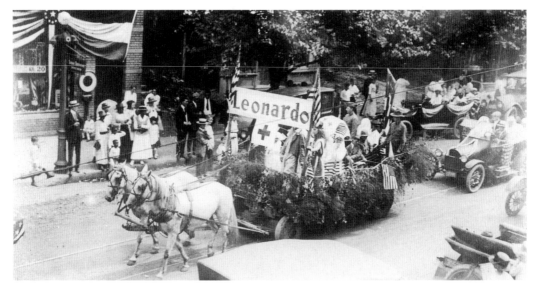

The marchers included about two hundred returnees from the Great War and a number of Civil War veterans. Several bands, local and out-of-town fire companies, and elaborately made-up floats provided color. The Red Cross is the float illustrated; others included "The Girls Behind the Men Behind the Guns," "Miss Peace and Her Fairies," "The Farmerette," and "The Refugee." The soldiers and sailors received medals in the morning at a ceremony at the Navesink Library and again in the afternoon following a talk by Middletown's Colonel William Barclay Parsons. Special tributes were paid to Paul Brunig and Franz Friedlander, who were killed in the war, and to Earl Williams, who died in France.

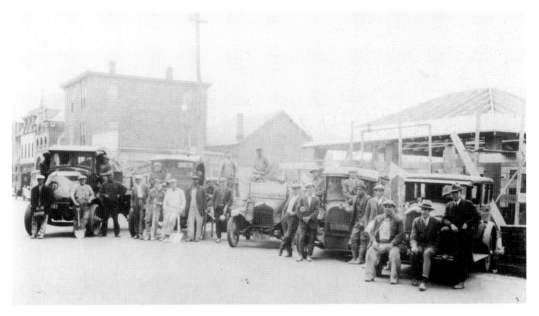

Ed Stone (at right), the employer of this construction crew, paused for a picture while on a First Avenue job *c.* 1920. Some subjects have been named, although identities have not been tied to the faces. They include: Ben Layton, Abe Pleasant, Dominick Caruso, Tookie Letts, Silas Jackson, John Stout, Jimmy Caruso, Honey Oakes, and John Manigrasso.

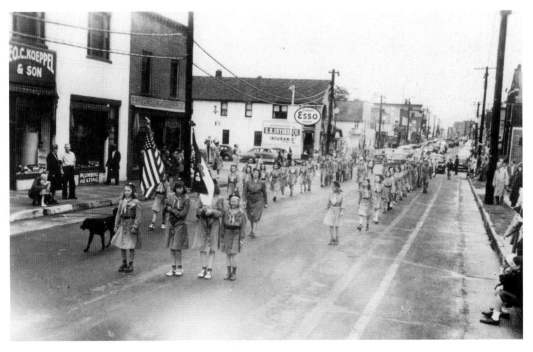

A parade, believed to be on Memorial Day, 1946, marches south. Can any of these Girl Scouts identify themselves today? The station behind the ESSO sign is on the bottom of p. 50. Behind it is 135 First Avenue, the longtime home of Gardiner Marek's insurance agency.

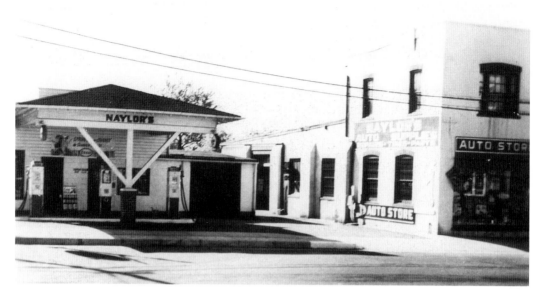

Naylor's automotive businesses spread across the west side of First Avenue on the block from West Lincoln to West Washington. His Pontiac dealership was on the corner, south of this *c.* 1930s gas station. An auto parts store was in mid-block, while the later station (shown below) was built on the Washington corner. This gas station is now a bakery, while George C. Koeppel & Son occupies the former auto parts store.

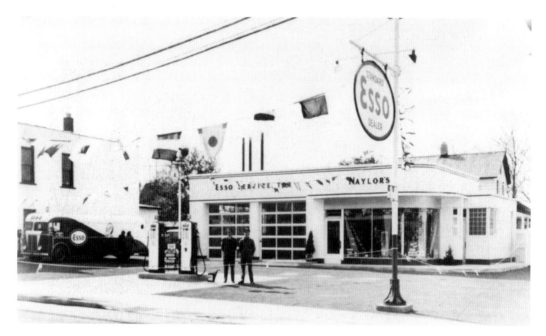

ESSO changed its name to EXXON, one of industry's costliest re-identification projects. The station at the southwest corner of First and West Washington is one of the First Avenue businesses appearing in these photographs that remains in its pictured location (although the building is a replacement). This photograph is from the 1940s.

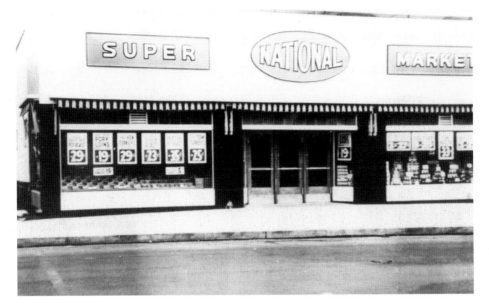

The retail mix of all towns changes over time, with supermarkets a prime indicator of this trend. They generally began smaller than the National store that took up a good portion of the east side of First, between Highland and Washington Avenues. This one was later a Safeway and was remodeled for non-retail use in 1969 by the Red Bank architectural firm of Kobayashi and Bostrom. By then, a growing population and an increased need for parking sent most small town supermarkets to the periphery of the old shopping areas, often on a highway. The borough's surviving supermarket's relocation to Highway 36 effected a noticeable change in the retail character of First Avenue.

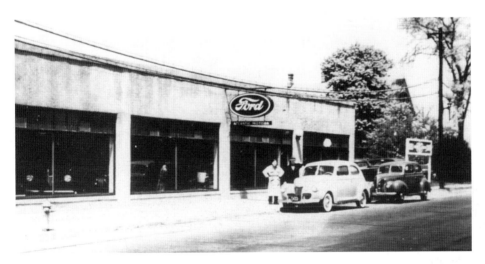

A now-vacant building on the west side of First Avenue at Garfield is a reminder of the early automotive strip once on southern First Avenue, housing at least four dealerships. Car dealers sometimes established new strips on well-traveled roads, outside the town centers they formally occupied. The lack of automobile showrooms near Atlantic Highlands today is one indicator of the movement of the local population center and the changed retail character of the town. This is a *c.* 1940 view of Mount-English's Ford showroom.

Left: A youthful Babe Kaufman enjoys a dip in the surf in 1924, four years before she entered the coin machine business of her husband. Widowed at an early age, she gained fame for success in a business that was virtually a male preserve. She lived on Hooper Avenue, the site of a large 1953 party of "The Cash Box" Twenty Year Club.

Below: This now-vacant building at the west side of First Avenue and Highland is the former Babe Kaufmann warehouse. She was, at different times, a jobber, distributor, and operator of every type of coin machine. One innovation was the advertising and sale of reconditioned juke boxes. Long before the liberation movement, "the Babe" achieved success in a male-dominated business by traditional applications of intelligence, ingenuity, and hard work.

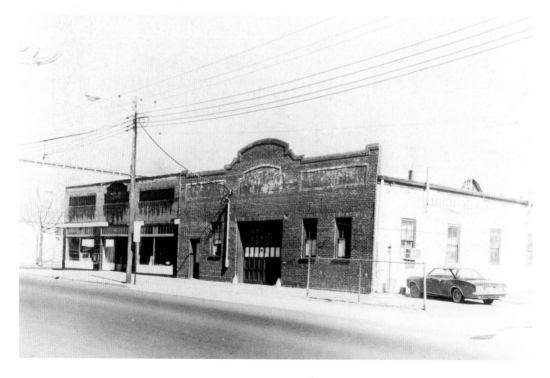

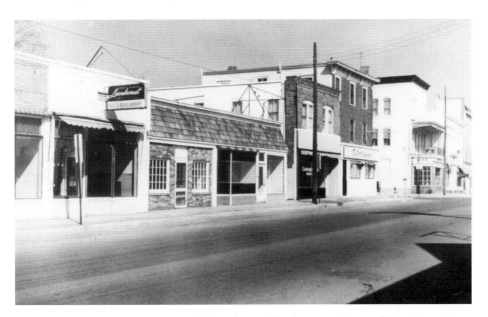

A planned urban renewal project would have changed the character of most of First Avenue in the late 1960s. Rejected by the voters, the borough focused attention on revitalizing one block, both sides between Mount and Highland Avenues. This entire retail block was demolished and left clear as a park, which contains the American Legion Catholic War Veterans Memorial. The picture, snapped in anticipation of the street's demise, was taken by Herbert S. Meinert, an educator long-interested in photography.

Retaining the Monmouth County National Bank in town, successor to the Atlantic Highlands National Bank, motivated the block clearing project. This one-story structure, designed as "formula colonial," was opened in 1971, with the bank relocating from 91 First Avenue, its home since its 1923 relocation from the foot of First Avenue, the building on the top of p. 35.

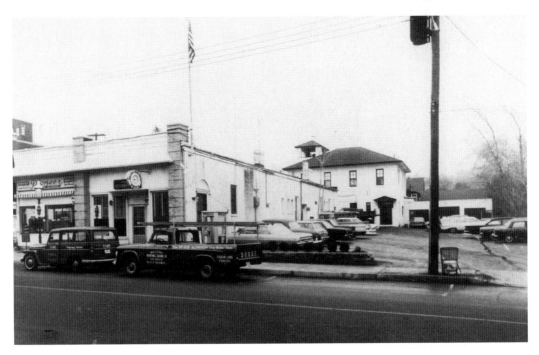

By the time this c. 1968 photograph was taken, the borough had long-outgrown its facilities, needing additional and new space to house several municipal units. The police station was adjacent to the Pioneer Market. After the new borough hall was built to the right, the two illustrated buildings were demolished for parking. The fire house (see p. 123) is in the rear. (Collection Atlantic Highlands Historical Society.)

The new borough hall was designed by James D. Witte. After a protracted planning period, construction began in the spring of 1969 and was completed the next year. The building was dedicated on July 4, 1970.

four

Hotels and
Houses

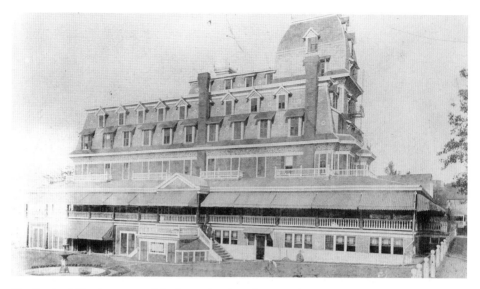

The Portland Hotel was one of the largest hotels and was, perhaps, Atlantic Highlands' most important. It was built in 1893 by Ezra Champion, ran into financial difficulties, and closed temporarily in 1894 while its finances were reorganized. The underinsured hotel was totally destroyed by fire on January 2, 1903, with the night's rain and favorable winds helping to save the adjacent house. The site at 54 Ocean Boulevard. is the location of the house on the left in the photograph on the bottom of p. 26.

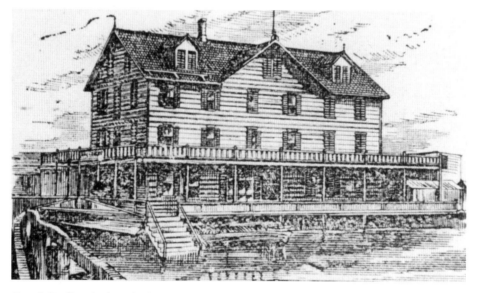

Foster's Pavilion, built at the foot of the dock in 1880, was the beginning of public accommodations at Atlantic Highlands. The building had four bedrooms, in addition to the kitchen, dining room, and hall. It was destroyed by fire on February 9, 1883, and rebuilt on the same site, but moved from the shore in November 1891 when the pier was rebuilt to accommodate the Central Railroad steamers. This view is from the July, 1888 *Atlantic Highlands Register*. In the early years, the hall was the site of numerous public meetings and even early church services. The site is vacant now.

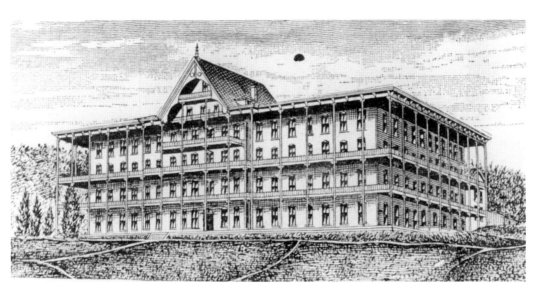

The Grand View Hotel was built in 1882 on the south side of Ocean Boulevard by Williamson and Parker, who purchased Atlantic Highlands Association lots. They were sold at a nominal price in view of the benefit the hotel would bring the emerging town. The underinsured building was totally destroyed by fire on Saturday, September 15, 1894. This view is from the July, 1888 *Atlantic Highlands Register*. Two private houses now occupy the site east of Grand Avenue.

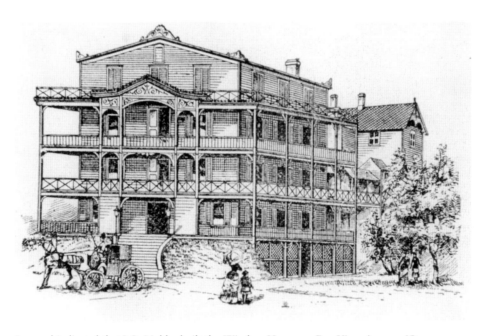

Leonard indicated that J.C. Nobles built the Windsor House on Bay View Avenue (Ocean Boulevard) in 1882. It seems that the place had an earlier occupancy, as the *Red Bank Register* of April 7, 1886, reported that Mrs. Edward (Elizabeth) Hooper would open the Windsor House, formerly Thorn's ice cream parlor, and indicated that it was situated near Grand View, where she could expect a large patronage. This view is from the July 1888 *Atlantic Highlands Register*.

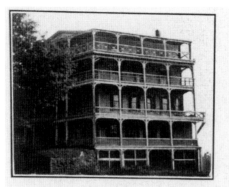

AT BEAUTIFUL
ATLANTIC HIGHLANDS

A rare combination of seashore and mountains. Two- to five-room furnished apartments. Verandas overlooking Bay and Ocean. All modern improvements.

Bathing houses, pavilion and boats two minutes from house.

Here may be enjoyed the finest still water bathing on the Atlantic Coast.

BRANDON APARTMENTS

Corner Bay View
and Sixth Avenue

ATLANTIC HIGHLANDS, N. J.

TELEPHONE

Atlantic Highlands

IDEAL for COMMUTERS

A delightful sail of one hour on Sandy Hook boats. Get off at Bay View Avenue Station; one minute walk to house; or take Steamer Mandalay; ten minutes walk from pier.

ELIZABETH H. RICE, Manager

The Windsor added a floor, and by 1920 it was an apartment house. It may have been only a ten-minute walk from the Mandalay Pier, but it was a steep, uphill hike. One wonders if there is a tie between Elizabeth Hooper and Elizabeth H. Rice. A brick ranch house is on the site at the block bounded by Sixth and Seventh Avenues and Ocean Boulevard. (Collection of John Rhody.)

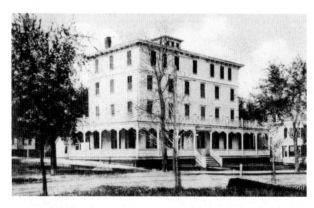

BAY VIEW HOUSE,

Centrally Located on the Water Front,

FIRST ESTABLISHED AND MOST POPULAR FAMILY HOUSE IN

Atlantic Highlands, New Jersey.

NO HEBREWS TAKEN.

RATES: Transients, $2.50 to $3.00 per Day. $10 to $25 by Week.

Open from June to October.

Mrs. C. R. Martin, Proprietor. Randolph Martin, Manager.

Left: Leonard indicated that, in 1880, at the behest of Mrs. Harriet E. Martin, he built the Bay View House at Ocean Boulevard and Third Avenue, after convincing Mrs. Martin to open her business in Atlantic Highlands, then known as Bay View, instead of Asbury Park. It was the town's first large boarding house, attracting its initial boarders the day it was finished, July 17, 1880. It was three stories then and the balustrades were simple rails. A brick ranch house is on the site now.

Right: The Bay View House was not the only discriminatory establishment, but the open practice of bigotry there was opposed, as indicated in this April 10, 1889 report in the *Red Bank Register.* "The manifesto of certain cottage owners at Atlantic Highlands against renting their houses to Jews has caused much discussion and many of the best people in town deprecate the action as unwarranted and unnecessary. They claim that it will be injurious to the place. While they admit the right of property owners to exclude any class of people, they argue that a public combination and circular against any particular sect is highly improper and likely to result injuriously to the whole people."

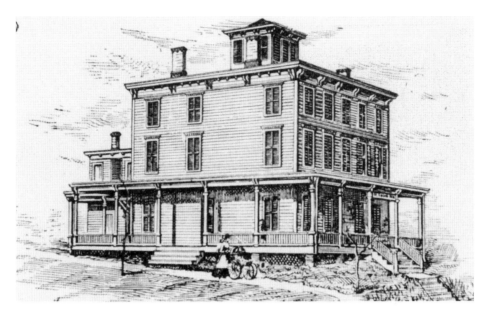

George W. Lockwood's city business was a New York fish market at Broadway and 48th Street. He built the Lockwood House *c.* 1885 at the southwest corner of Ocean Boulevard and Fourth Avenue, a simple structure in the waning Italianate style. This view is from the July 1888 *Atlantic Highlands Register.*

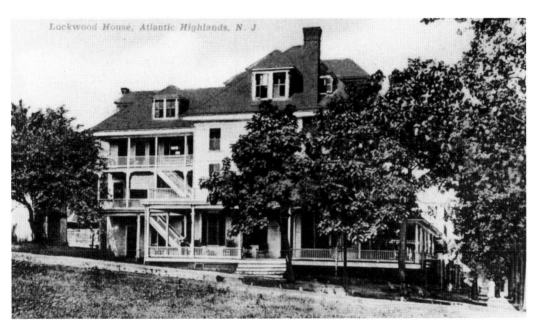

The Lockwood was expanded over the years. This *c.* 1910 postcard appears to be the same perspective, suggesting a chimney was added, in addition to the obvious changes of building up the rear extension and replacing the tower with an additional half-story. The Lockwood was destroyed by fire on June 15, 1929, shortly after being purchased by Grantley Squires, who was remodeling with plans to open for the season. A brick ranch house is on the site now.

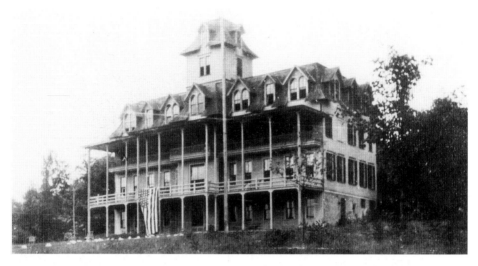

This postcard is clearly marked, "Oxford Hotel, Atlantic Highlands," but no trace of the establishment has been found. It is one of the author's favorite pictures as it sports a tower and an extravagant expanse of porches and dormers. The locale appears to "fit" an Atlantic Highlands hillside, but where?

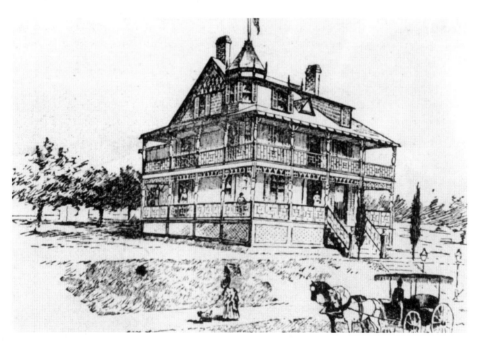

Mrs. M.B. McMartin's Mitchell Cottage was built in 1883 on the east side of Fourth Avenue. She advertised as follows in the October 1884 *Atlantic Highlands Mutual,* a monthly newspaper: "The Mitchell Cottage, Beautifully situated in one of the Most Attractive Regions on the Coast, one and one-fourth hours from New York, Will Receive Guests May lst. Cottage and Appointments First Class. Delightful Home For Select Families and Parties. Closest inspection invited and highest references given." The house no longer stands; the property is vacant, with the date or cause of loss of the house unknown.

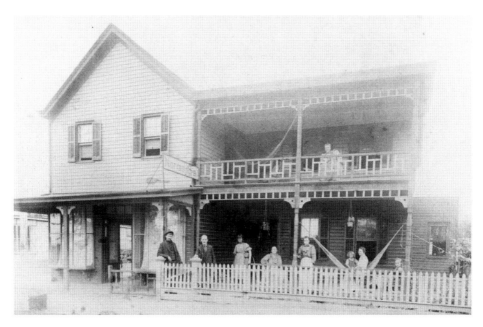

A boarding house was opened at the southwest corner of Bay Avenue and Avenue A sometime in the 1880s. The Normandie was its name in the 1890s, after Mrs. Ludwig Jacobsen bought the house from Mrs. H.C. Both. Two houses were joined, the section with the front gable apparently being original to the site. The building is now a private residence with changes in windows and decorative elements.

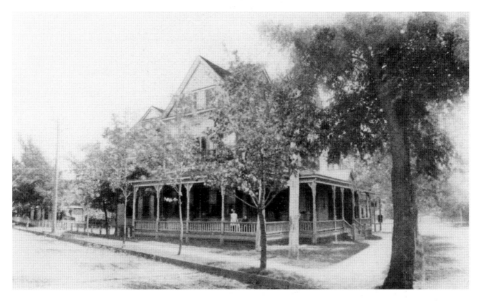

According to an ad in the 1904 Norton's Directory, Henry Sterling's West End Hotel, at the northeast corner of Center Avenue and Avenue D, offered special rates to families, was open all year, and featured a ladies' and gents' cafe, as well as billiards and pool. The West End was destroyed by fire in the early 1950s, after its name was changed to the Homestead. A c. 1960s bi-level private house is now on this corner.

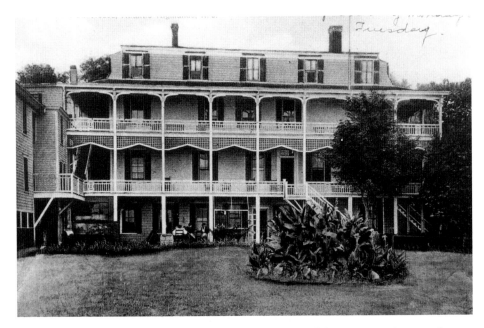

Mrs. A. Pope, an experienced New York hotel operator, opened the Sea View House on the hillside overlooking Sandy Hook Bay in 1882. The Bay View Avenue railroad station was later built a few yards away (see p. 13). The building was expanded over the years and was long one of the town's largest hotels. It was taken down at an unspecified time, and there are now houses on the site. This view is from a *c.* 1910 postcard. (Collection of the Atlantic Highlands Historical Society.)

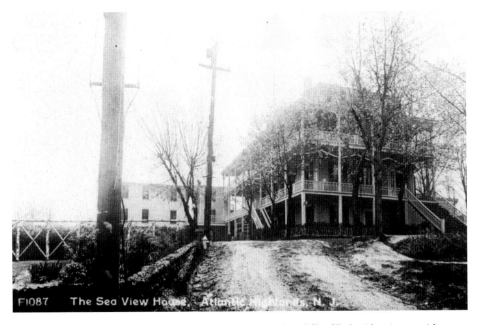

A second view from the side shows the expansion wing. The cliff is filled with private residences now. (Collection of John Rhody.)

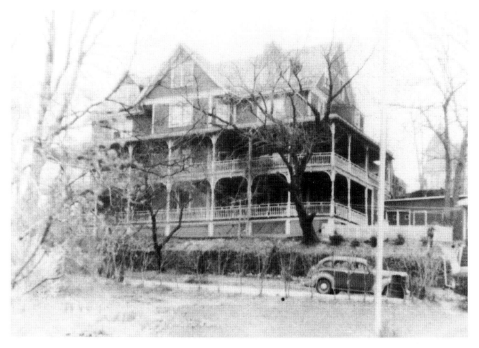

The Hollywood Lodge, later known as the Hollywood Hotel, a boarding house on the block around Mount, Highland, and Eighth Avenues, was conducted briefly by Robert Emery as a post-retirement venture, c. 1905. Its high elevation gave it a view of Sandy Hook Bay. It no longer stands. (Collection of the Atlantic Highlands Historical Society.)

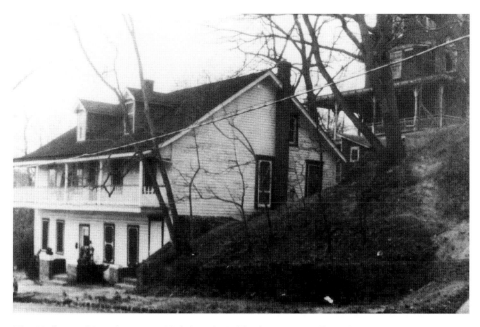

The Hollywood Hotel annex at Eighth and Highland Avenues still stands, converted into a private house. (Collection of the Atlantic Highlands Historical Society.)

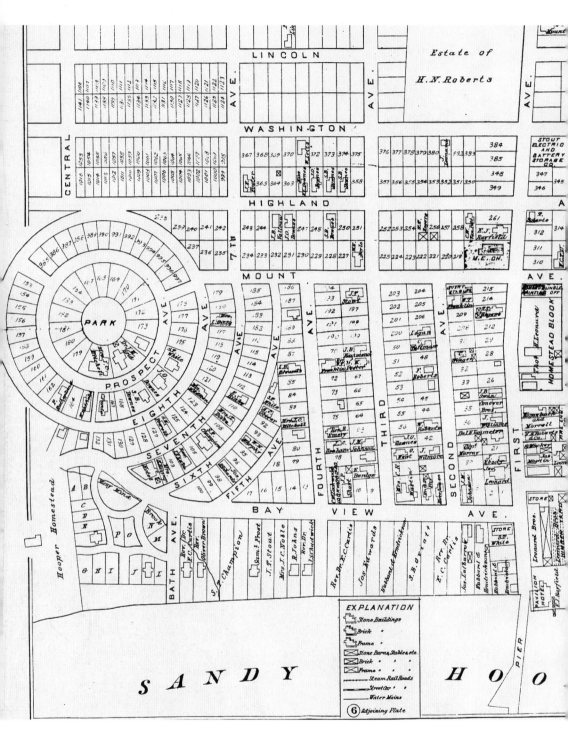

The importance of Atlantic Highlands at the 1889 publication of Wolverton's *Atlas of Monmouth County* may be inferred from its receiving two large-scale double-page maps, the only small town so mapped. Note the homes of three of the farms that formed Atlantic Highlands: Hooper (on the lower left), H.N. Roberts (at top), and Thomas Henry Leonard (in the middle of the business district). If the numbered

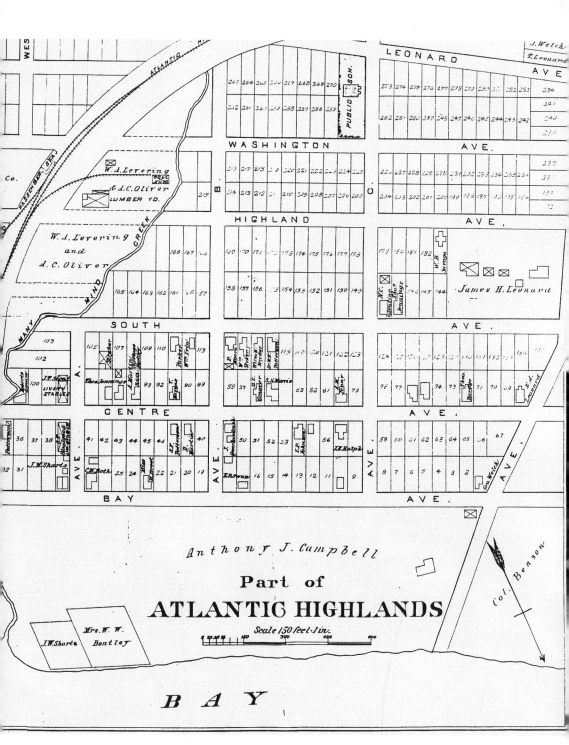

Part of

ATLANTIC HIGHLANDS

Scale 150 feet 1 in.

BAY

streets seem inconsistent, consider that the initial map of Thomas Henry Leonard's building lots covered a rectangle bounded by First, Bay View, Third, and Mount Avenues. Fourth Avenue was then one block from Bay View to the bay. The circle streets came later and only First, Third, and Seventh extend south beyond Mount.

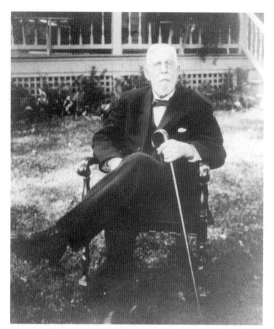

Dan Frost was an Indian trader, conducting a New York City business in their wares and materials. He named his home Howkola. Its meaning was revealed to Joan Smith, the present owner, and an audience of millions, by a Native American on national television who explained it was a gesture of greeting, "Welcome to my home." This is a late-life portrait in the collection of the Atlantic Highlands Historical Society. The Frosts sold the house in 1929

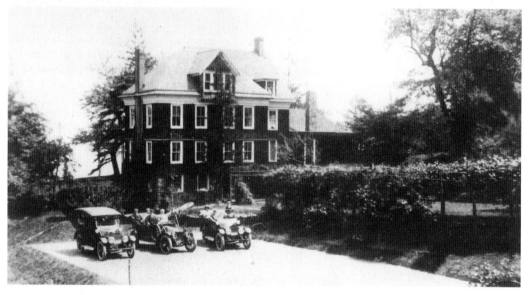

No. 170 Ocean Boulevard was the home of Charles Sears from 1856 to his death in 1890. Sears was a founder of the North American Phalanx, a planned cooperative community once located at present-day Colts Neck. They used marl extensively to enrich Phalanx soil. Sears found the substance on his cliffside property, mining it for years. The property was named Point Lookout for good reason; it has a magnificent view of Sandy Hook, the bay, and New York. Charles Payne Sears, the artist, but not a son of the elder Sears, worked here, but did not own the property. The oldest section, facing the water, is not visible in this picture, having been enveloped by additions. The two-and-a-half story house is on sloping ground with the contours making the basement visible on the south, creating the impression of an additional floor. The property was mapped for development in 1892. (Collection of the Atlantic Highlands Historical Society.)

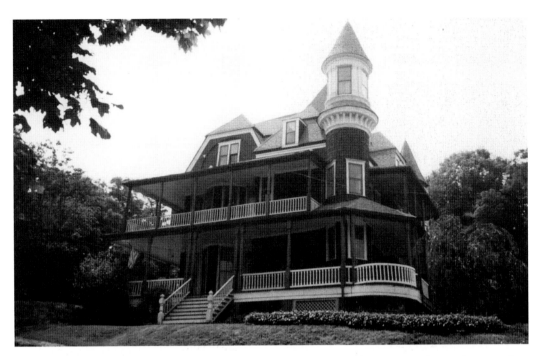

In 1893, Adolph Strauss built this cottage on the East Mount Avenue, block-long lot number 997 of the Atlantic Highlands Association running from Eighth to Prospect Avenues. The architect was Solomon D. Cohen of New York. Earlier called the Tower Cottage, the house located at 27 Prospect Avenue is now the Strauss House museum of the Atlantic Highlands Historical Society. Occupied by the Strausses for little more than a decade, the house was altered often. A news brief in the June 6, 1896 *Monmouth Press* indicated it was being expanded and remodeled after only three years. The house has a checkered recent history. It had been a rooming house and was in poor condition when condemned for demolition in 1979. The Society purchased it in 1981, beginning a long and costly restoration. This picture, taken in 1995, disguises the countless hours of care and work that transformed a blighted wreck into the pride of Atlantic Highlands.

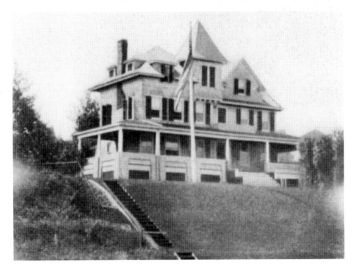

The Ida Peck House is one of the row of primarily 1890s Queen Anne-style houses above the harbor on Ocean Boulevard that creates a fine first impression of residential Atlantic Highlands for maritime visitors. It is shown here as it appeared in W.J. Leonard's 1903 *Seashore Souvenir*, shortly after the home's 1901 remodeling.

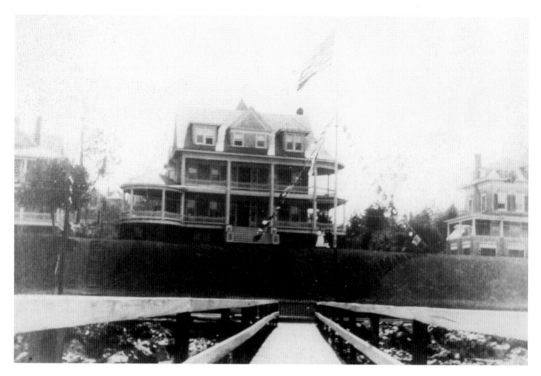

Above: The Pavonia Yacht Club erected a clubhouse on the shore of Sandy Hook Bay, completed in July 1890. They had about one hundred members then and a fleet of approximately forty boats. Their headquarters was remodeled as a private residence in 1905, the changes designed by Thomas J. Emery. It stands at 48 Ocean Boulevard.

Left: Adolph Strauss, born in 1829, was a German immigrant, arriving in the United States in 1856. He founded a New York notions importing business and lived in the city on East 49th Street. Strauss built the house at the top of the previous page as a summer home. He died *c.* 1907. (Collection of the Atlantic Highlands Historical Society.)

 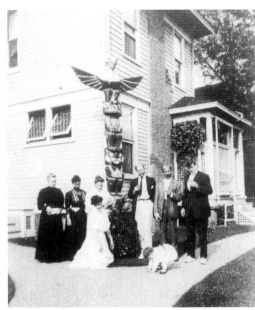

These women convey the impression that no one is going to compel them to enjoy themselves at Howkola. Perhaps they were disoriented, as a companion picture (not published) shows them under the porch with their hats on! Frost decorated the grounds with a totem pole.

The Atlantic Highlands Historical Society has been guided by a number of dedicated leaders, including Bob Schoeffling (left), their first president. Bob led the group in two separate tours of duty, including the critical early years. Fanny McCallum (shown at right with husband George) was for many years the heart and soul of the organization. Her greatest accomplishment, among many, was the turning of a vacant house, the subject of extensive restoration, into a museum. Leading the Society was the culmination of a long, varied career of public service, which included the presidency of the Atlantic Highlands Board of Education and the chair of the Atlantic Highlands Planning Board.

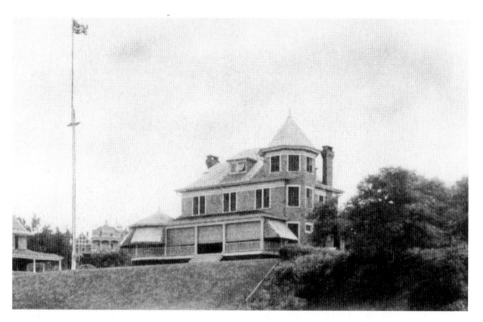

Captain Joseph Barre's 1898 Ocean Boulevard house is fittingly called Barre Harbor. Its white marble cornerstone was installed with a box containing coins and local newspapers of the year. This view is from W.J. Leonard's 1903 *Seashore Souvenir*, after the 1901 erection of a two-story addition with a billiard parlor on the lower level and a balcony upstairs.

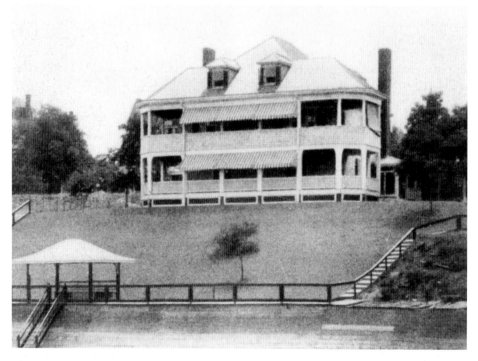

This image of William S. Auchincloss' Ocean Boulevard house is also from the W.J. Leonard's 1903 *Seashore Souvenir*.

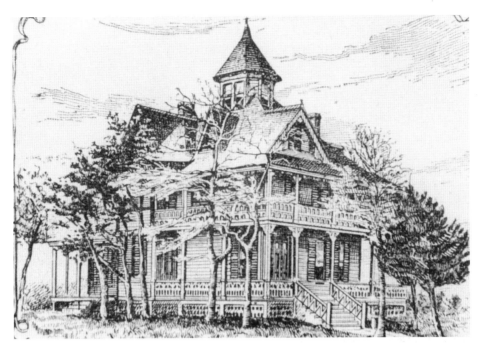

The Reverend Dr. E.C. Curtis, president of the Atlantic Highlands Association, built this house between Bay View Avenue and the bay in late 1885. This view is from the July 1888 *Atlantic Highlands Register.*

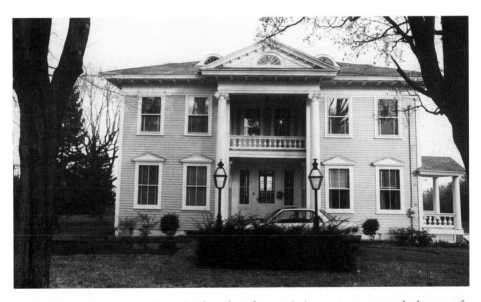

The Oscar Unz House at 54 Ocean Boulevard can be seen in its street context on the bottom of p. 26. It breaks the "Queen Anne line," having been built in the next decade (1907) when the Colonial Revival began its influence in a town with an admittedly Victorian character. The house was designed by Thomas J. Emery and built on the site of the Portland Hotel (see p. 56) which burned in 1903. The porches have been removed, but the house's integrity is intact, representing one of Atlantic Highlands' finest Colonial Revival buildings and one of Emery's best works.

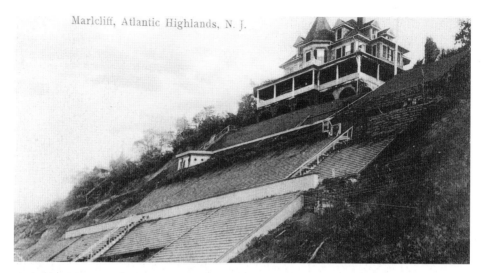

Marlcliff, Atlantic Highlands, N. J.

The cliff-side construction has long puzzled viewers of this *c.* 1910 postcard. The *Monmouth Press* of October 22, 1904, provided this description: "Mr. E. Jensen, who has spent hundreds of dollars in endeavoring to keep the bluff in front of his residence from washing away, has now a new scheme. From the railroad track at the foot of the bluff to the top it is about 150 feet. He has had Contractor Geary erect abutments at the foot of the bluff and from these abutments long and heavy poles have been placed on top of the soil. The poles are joined together with heavy timbers and the whole thing boarded over and covered with a patent tar paper roofing. A strip 32 feet wide has been covered in this manner from the foot to the top and if it proves successful the entire bluff will be covered in the same manner. Gutters and drains have also been placed about midway down the bluff to carry away the water that is continually oozing forth." (Collection of the Atlantic Highlands Historical Society.)

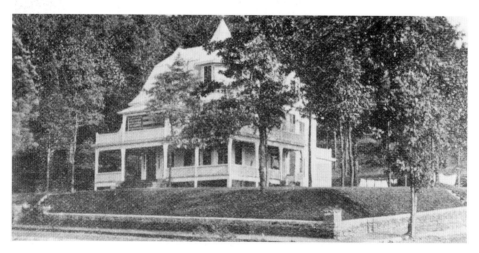

John C. Lovett's house, at the southeast corner of Ocean Boulevard and Auditorium Road, was designed by Thomas J. Emery's office during his brief association with John C. Moore. It had the characteristic tower, but its square plan and sloping gambrel roof mark it as having been built at the beginning of Emery's Colonial Revival period. Nicknamed the Florence, the house was built in 1898 and published in Emery's booklet. The fence remains, but the Florence suffered two fires *c.* 1950s, the second resulting in its total destruction. A modern house is there now.

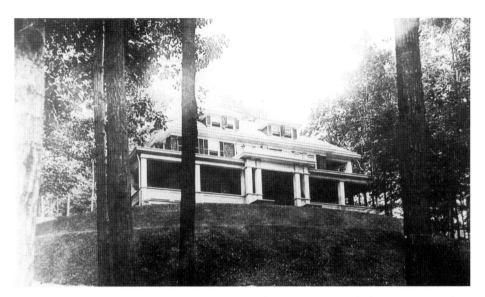

Alonzo C. Case, a New York City lace merchant, built this fine Colonial Revival house, architect unknown, on a high hill overlooking the bay *c.* 1910. He sold it in 1927, having built a new house on Navesink River Road in Middletown, but moved back to Atlantic Highlands after the unexpected death of his wife in 1929. Case's house, still standing with the porch enclosed, formerly had a Hooper Avenue address, but is now accessed through Keystone Drive.

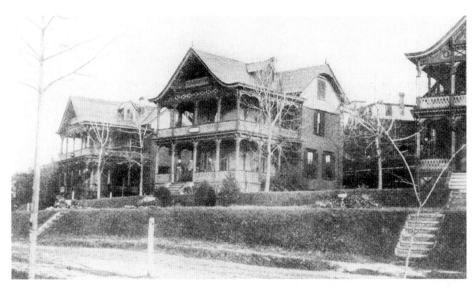

These three houses, described in the Emery booklet as merely "Some Cottages on one of the circle avenues. One to left, the Clarence," are at 10, 12, and 16 Eighth Avenue. The one in the middle is no longer there and perhaps was moved nearby. The one on left is S.B. Downes' house, built in 1882, probably designed by Henry E. Ficken, a name not readily discernible on the surviving fragment of a building contract. The center one belonged to J.O. Downes, associated with Samuel in the S.B. Downes & Co. The building partially shown at right is the 1885 Samuel T. White House, designed and built by Robert Emery. The surviving houses are readily recognizable today, despite alteration of their trim.

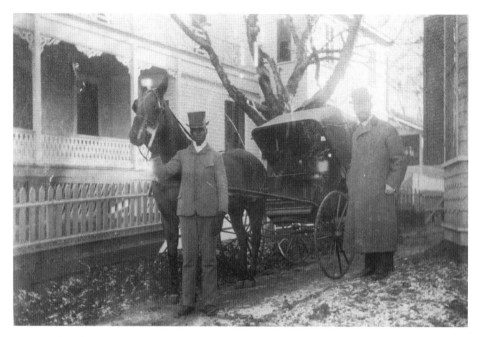

Dr. George Dewitt Fay was an Eatontown native, the son of the Reverend James Dewitt and Elizabeth Worthley Fay. He graduated from Hahnemann Medical School in Philadelphia in 1881, opening an Atlantic Highlands office soon thereafter. Fay was long-active in local civic affairs and was a trustee of the Methodist church. He died in at the age of seventy on March 7, 1928. He is shown here *c.* 1890s. (Collection of the Atlantic Highlands Historical Society.)

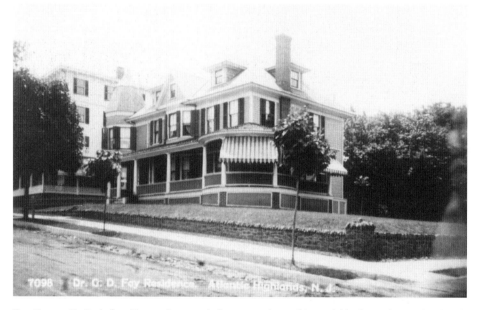

Dr. George D. Fay's fine Queen Anne-style house was located in mid-block on the south side of Ocean Boulevard, adjacent to the Bay View Hotel on the east, visible at left. It was demolished *c.* 1950, with apartments now on the site. (Collection of John Rhody.)

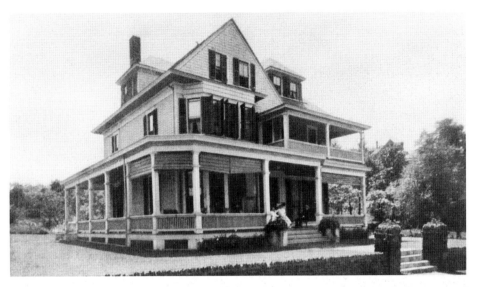

Local Hoopers claimed descent from William Hooper, who signed the Declaration of Independence for North Carolina. Their waterfront farm was worked for most of the nineteenth century prior to 1879, when Edward Hooper sold it to the Atlantic Highlands Association. The house, once near the water east of today's harbor, was moved to the southwest corner of Ocean Boulevard and Grand Avenue and altered in 1901 to a Thomas J. Emery design. This view is from W.J. Leonard's 1903 *Seashore Souvenir*. The house still stands, but it is not recognizable following alterations, including moving the grade to cover the first floor.

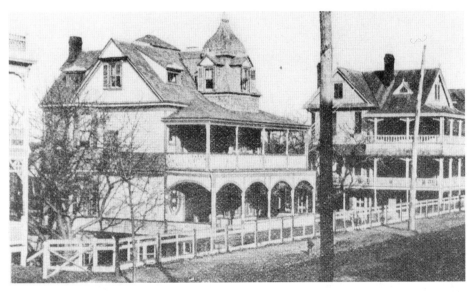

The "E" in the stained glass on the front door of 29 Fourth Avenue is for Robert Emery, the clergyman and builder who erected this Queen Anne-style house in the early 1880s. When he vacated in 1894, the *Monmouth Press* referred to it as, "the first expensive residence erected in Atlantic Highlands." The house remains, its integrity largely intact. The old balustrades are gone and a room has been built-in at the spot of the side dormer on the third-floor. The house at right no longer stands. (A view from the Emery booklet.)

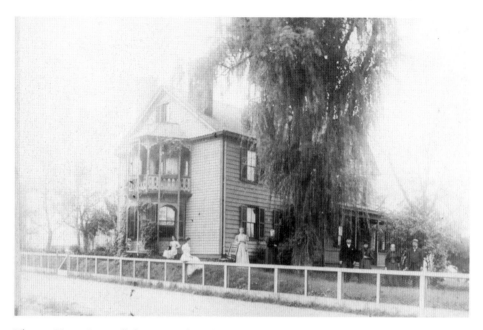

Thomas Henry Leonard's house stood on the west side of what became First Avenue after he had part of his farm laid out in lots in 1879, between today's Mount and Center Avenues. The street was called the "Homestead Block," well after the house was moved to the northeast corner of Second and Mount Avenues.

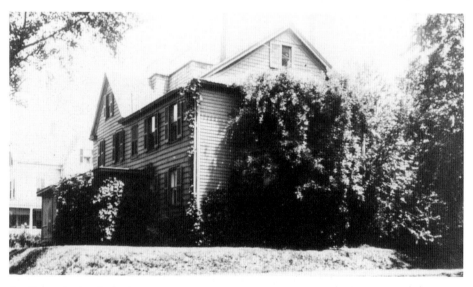

Dr. Henry A. Hendrickson married Thomas Henry Leonard's daughter Clara on October 18, 1893. Some years later, the Leonard home was moved from its First Avenue location on the northeast corner of Mount and Second Avenues, as it is shown here on a *c.* 1915 postcard. Ivy covers the house's south elevation bay, one of its clearly distinguishing characteristics. Hendrickson, fondly known as "Dr. Harry," served in a number of civic capacities, including three terms as mayor from January 1, 1920, to January 1, 1926. He died on July 27, 1933. (Collection of John Rhody.)

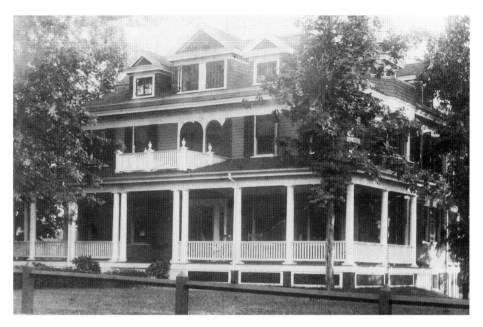

Charles E. Satterlee, an officer of the Texas and Pacific Railway, built this Colonial Revival house on the southwest corner of Lincoln and Central Avenues in 1902. It is named Rimwood, but regrettably its architect is unknown. (Collection of Posten Funeral Home.)

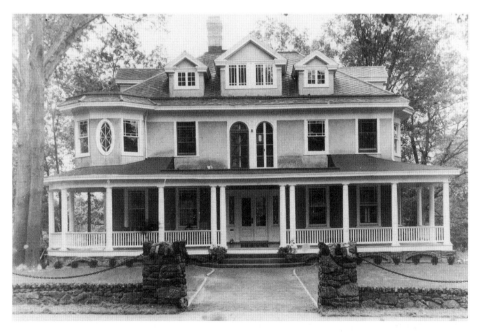

Rimwood was sold to Harry and Herbert Posten in 1945 and was remodeled as a funeral home. The house's integrity is intact and one might not notice the subtle differences without comparing the pictures. The stuccoed exterior is rather noticeable, but note also that the second-floor balcony was removed and windows were changed. (Collection of Posten Funeral Home.)

Right: Robert Bruce Mantell was born in Scotland on February 7, 1854, and first appeared on the American stage at age four. He returned home, emigrating to the United States in 1883 and moving to Atlantic Highlands in 1905. Mantell also appeared in romantic plays, but in his later career he was regarded as America's greatest tragedian. He was married four times and had four children. Mantell traveled often, but was active in local civic affairs. His financial support of Grand View Hose Co. No. 2 occasioned their renaming themselves Robert B. Mantell Hose Co. No. 2. He died at home on June 27, 1928. (Collection of the Atlantic Highlands Historical Society.)

Below: James H. Leonard married Emma C. Taylor in 1863 and bought the Debow farm around the same time, building this substantial house known as Cherrywood. Robert Mantell acquired it *c.* 1905, and renamed the twenty-two-room house Brucewood. The grounds contained a garage known as The Studio, where the actors rehearsed. It was saved during a 1931 fire that destroyed a nearby barn, just prior to the property's acquisition by Andrew Richards. Although he was reported to have contemplated building a hotel on the site, the Avenue D house still stands, now occupied as the St. Agnes' thrift shop.

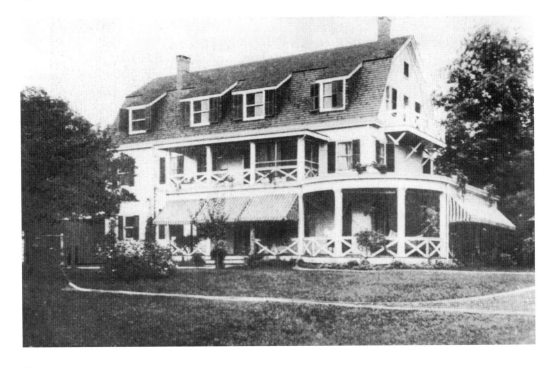

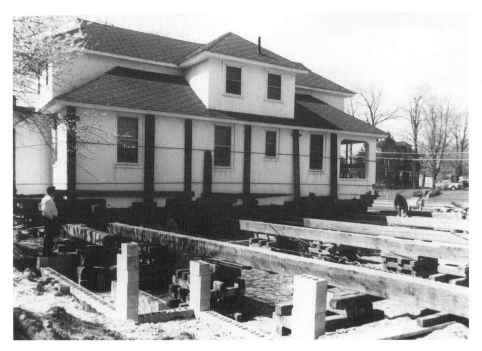

The Memorial Parkway home of Michael and Mary Cassone was built by Mike's father in the 1920s. He purchased three lots then, forethought that proved crucial when the road was dualized and a turning jug-handle built. They owned the lot to the east and were able to move the house when the highway department took its original site. The house was moved in 1964 by Duffy Fisher, Middletown's well-known, one-man, house-moving operation.

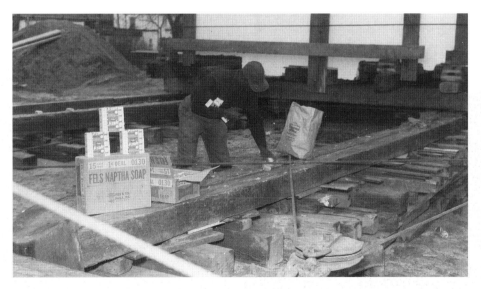

The road widening and erection of a barrier and turning lanes along a several mile stretch created a lot of work for Duffy Fisher in the early-1960s. He moved buildings without assistance, his long experience guiding him through the intricacies of the projects. The process involved liberal application of Fels Naptha soap along beams on which the structure would slide.

Edward L. Powell, a German immigrant plumbing engineer, built the Third Avenue house below with his own hands. He drowned on September 9, 1898, in a boating accident in Colombia, South America, while employed in a prospecting expedition. Maude, his daughter, shown here at age seventeen, was a skilled embroiderer. She married John H. Mount. They are the grandfather and mother of June Walling, who lent the pictures.

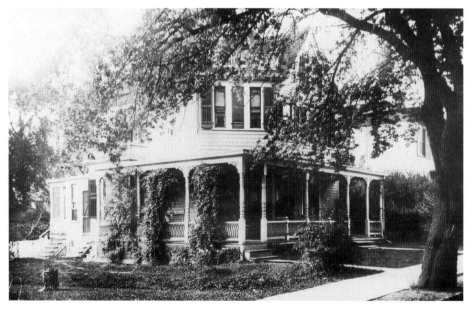

Edward Powell's house still stands at 33 Third Avenue, looking much the same as it does in this early century photograph, although it has been sided and the balustrades are gone.

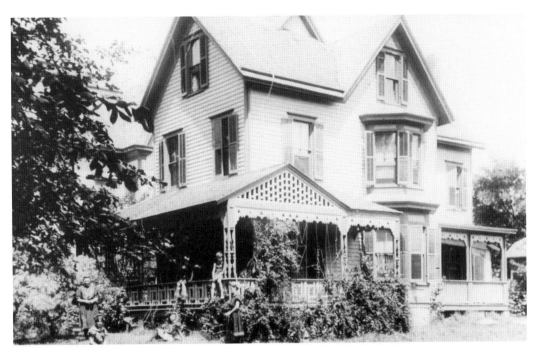

A family poses *c*. 1912 at a house that no longer stands. It was located on the southwest corner of Avenue D and South Avenue, and disappeared at a time unknown. A modern house is now on the corner.

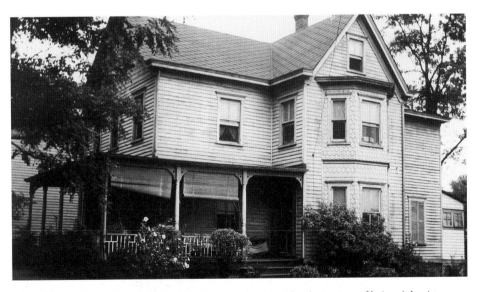

The Julia A. Elder House at 51 Garfield Avenue may have the distinction of being Atlantic Highlands' least-changed century house. The porch is still open, although the posts have been replaced, and its decorative and structural features are intact. The house, erected in 1892, was not designed by an architect; it was built by William Kipp, whose instructions—according to Monmouth Building Contract No. 3127—were to construct: "a duplicate of the residence formerly of Katy Brush on First Avenue, Hillside Park, near Atlantic Highlands."

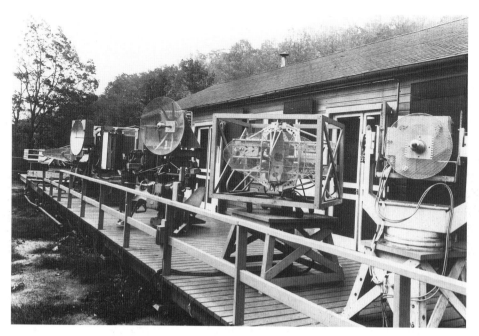

A small bungalow on the hill overlooking Sandy Hook Bay was selected in 1939 as a test site for the development of shipboard radar. A special laboratory building was erected in the spring of 1942. In addition, an antenna on top of a 100-foot tower was built after a zoning exemption was obtained. Work there helped convince officials that radar could accurately direct naval gunfire. The experimental buildings are now houses at 60, 66, and 72 Bayside Drive.

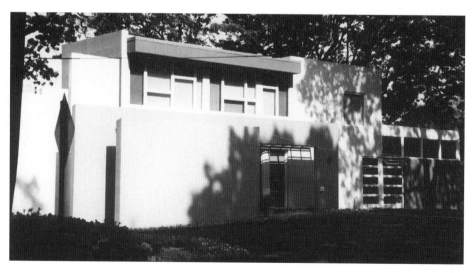

An ordinary 1950s ranch house at 198 Ocean Boulevard was transformed in 1990 to a dramatic statement in color and form. Morristown architect Vachie Simonian's planned remodeling turned into a complete above-grade reconstruction. The house was built on a hillside and included a massive, brick-clad concrete cylinder. The north, or water side, is shaped in a large arc, giving rise to its nickname, the Roundhouse. The flat surfaces of the south, or street side, have a sculptural impact and are painted in muted colors of blue, green, orange, yellow, and violet.

People, Places, and Events

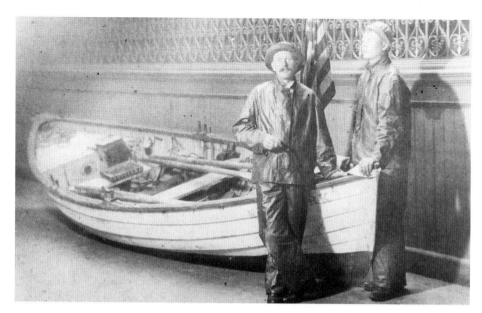

The maritime accomplishment of these two Atlantic Highlands Norwegian immigrants still staggers the imagination a century after its completion: they rowed across the Atlantic Ocean! George Harbo (left) and Frank Samuelsen departed from the Battery in New York on June 6, 1896, in an 18-foot, 4-inch boat with watertight compartments, carrying ten pairs of oars and provisions for about sixty days. The vessel was named the *Fox* for Richard K. Fox, publisher of the *Police Gazette*, which sponsored their effort. Rowing eighteen hours a day, braving rough weather, including surviving a storm that tossed them overboard, the intrepid sailors arrived at Le. Havre, France, on August 7, to a heroes' welcome. This rare family heirloom was lent by Norman and Spencer Samuelsen.

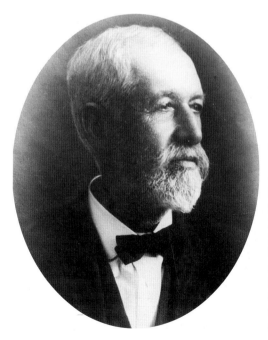

William F. Foster was born at Allaire, January 11, 1837. He enlisted early in the Civil War and was wounded three times. Foster had varied business ventures. Moving to Atlantic Highlands in 1880, he built the first boarding house-hotel, Foster's Pavilion. He helped organize the Methodist Church, the Atlantic Highlands Fire Department, and the Atlantic Highlands Casino, serving the latter as president or vice-president from its 1895 inception to his death. Foster was also the Atlantic Highlands postmaster. He died on September 26, 1911. (Collection of the Atlantic Highlands Historical Society)

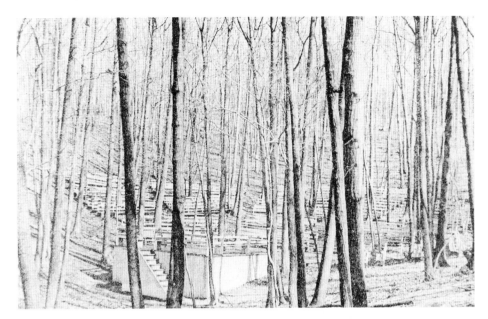

The amphitheater, also known as the auditorium, was an oval, natural depression in the hillside near Grand Avenue, with remarkable acoustic properties. Benches for about four thousand were erected. A variety of services and meetings were held here, including the Chatauqua Association in 1886. The amphitheater was dedicated on July 27, 1881. Unfortunately, its appeal as real estate was too great; it was cleared for building lots in 1893, and the site is now occupied by houses. This photograph was published several times in early town promotional works.

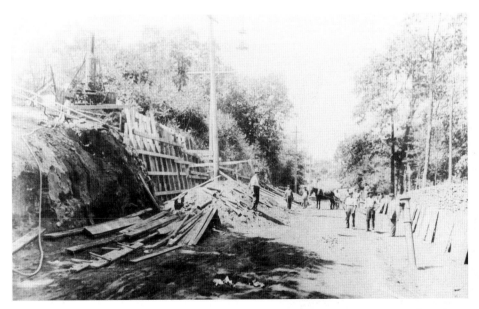

The borough expanded twice by annexing choice property near Sandy Hook Bay in 1909 and 1915. Ocean Boulevard was extended to provide an effective road connection for these acquisitions. Joseph Caruso's crew is shown here installing a concrete retaining wall in the area of Hill Road c. 1909. (Collection of the Atlantic Highlands Historical Society.)

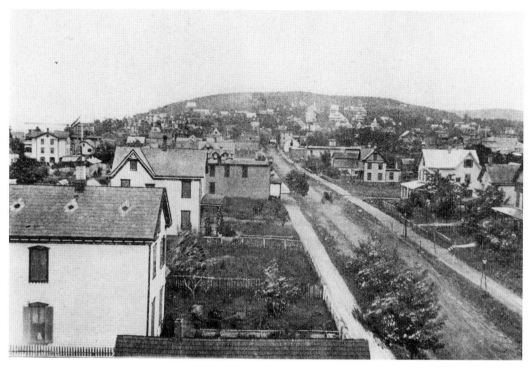

Above: This *c.* 1890 view east down Center Avenue provides a contrast of the east and west sides of town. The former consists of flat land with straight streets laid out on a grid. The hilly terrain east of First Avenue has an irregular street pattern, one best portrayed on the bottom of p. 121. The photograph is from the 1892 Board of Trade promotional booklet *Atlantic Highlands.*

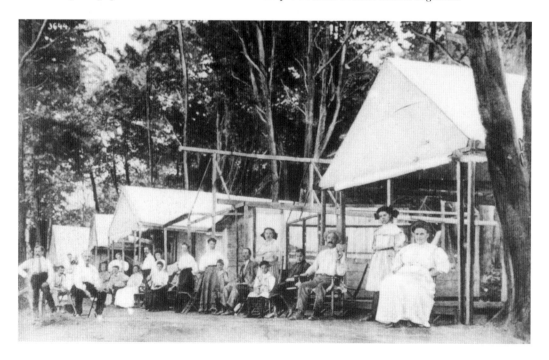

Above: Annie, the Camp Hilton cook in 1891, relaxes during break time. (Collection of the Atlantic Highlands Historical Society.)

Right: Walter Bills and Frederick Moller prepare for a three-legged race at an unidentified event, *c.* 1920. (Collection of John Rhody.)

Opposite below: A veritable tent city existed in the eastern stem of town, built around an area that was contemplated as an expensive summer home colony, but not built. The section was named for Judge Hilton. This vintage view is from a *c.* 1910 postcard.

The tennis courts were added adjacent to the Casino at some point after its 1896 opening. This image is from a c. 1920 postcard. A private residence is now on the site. (Collection of Ed Banfield.)

Esther Manning combined a shampoo label with a picture of an exotic woman to create a c. 1920s advertising postcard. Claiming all remedies for "Manning's head," she offered violet ray treatment. Operating from her home at 80 Lincoln Avenue, one suspects she was better at separating the "wary unhairy" from their money than in securing new growth.

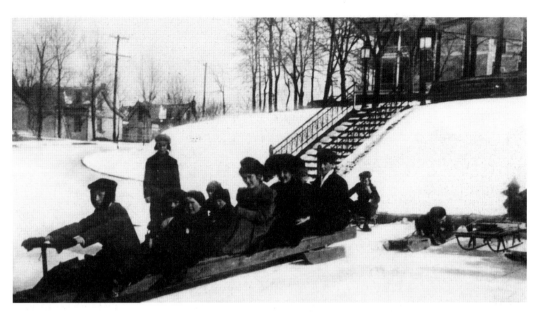

The *Red Bank Register* of January 25, 1893, reported: "Coasting is the popular sport at Atlantic Highlands now. The long steep hills right in the town form excellent toboggan slides and crowds of people both young and old are out every night enjoying the fun. Most of the sleighs used are bob sleds with four runners, capable of holding anywhere from a dozen to twenty at one time. The street lamps shed just enough light upon the scene to make the coasting agreeable . . . The principal slide is on Mount Avenue where a long coast of nearly a quarter of a mile is had. A number of sleds have been broken but no serious accidents have happened to their occupants." These postcard views were published after 1907. So, what can one do for comparable thrills today? Coasting down Mount Avenue in neutral is certainly not recommended. (Collection of the Atlantic Highlands Historical Society.)

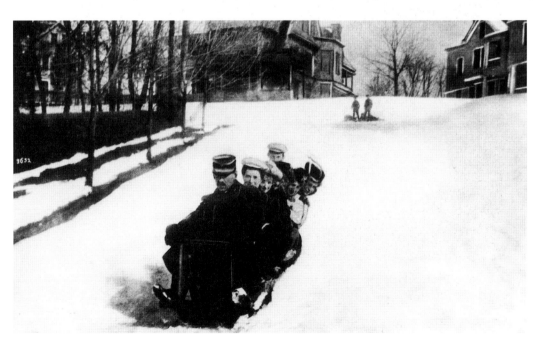

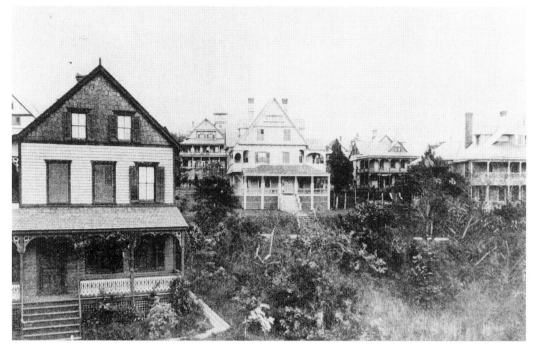

Above: Atlantic Highlands, the 1892 Board of Trade booklet, labels this photograph "Looking Towards Prospect Avenue from Fifth Avenue" (a one block dead end street). It conveys a key fire-fighting concern at a time when closely-built buildings presented a significant fire hazard.

Left: Hortense Ellis as a young girl. (Collection of the Atlantic Highlands Historical Society.)

Right: Calvin W. Miller was a native of the Lancaster, Pennsylvania, area. A carpenter by trade, he came to the shore area in the late nineteenth century for the erection of Lakewood's Laurel-In-The-Pines Hotel on December 22, 1897. He married a worker there, Josie Norcross, and settled in Atlantic Highlands, passing away *c.* 1960 at age ninety-six. He opened the warehouse below. (Collection of Ed Banfield.)

Below: Calvin E. Miller's warehouse at 6 East Washington Avenue was built in 1906. He opened the business the next year, initially appealing to tent-dwelling summer campers who had been storing their rigs and effects in local barns. He branched into storing household furniture and automobiles and had a fireproof vault for silverware and other valuables. The building, now painted yellow, appears today much as it does in this early century view, with some changes to doors and windows. This picture is from the collection of Ed Banfield, who occupied the building from 1947–70.

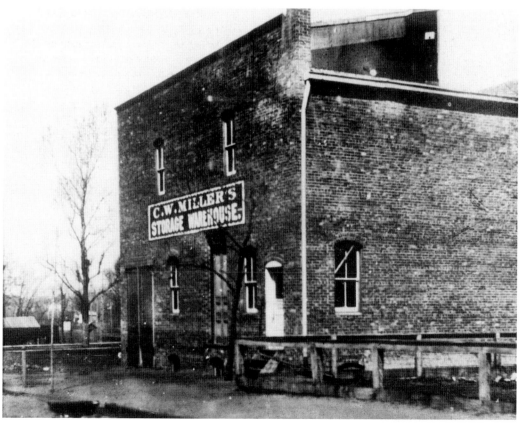

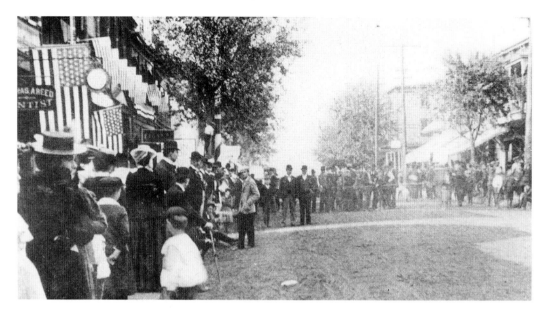

Thomas J. Emery, Atlantic Highlands' leading architect, claimed to be its first real estate agent, and sold insurance. Perhaps that was not a full work load, as he also sold bicycles, cycled extensively, and was an official of the League of American Wheelmen. This picture from the Emery booklet shows the crowd waiting for a bicycle race in front of his shop on lower First Avenue on May 25, 1898.

 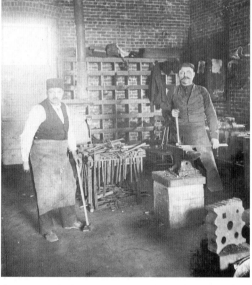

August Dauster, born on December 5, 1872, in Weyer, Germany, emigrated to the United States in 1898, having been trained as a blacksmith and iron worker. He came to Atlantic Highlands after a short stay in Hoboken, working in Tonies Moller's blacksmith shop, which he later bought after a seventeen-year stint as a post blacksmith at Sandy Hook. That position included a trip to Mexico with Pershing in 1916. Dauster raced and built boats and fished. His shop specialized in tools for the fishing trades. One of his rakes can be seen at the top of the next page. In the photograph on the right, Dauster (right) poses with an unidentified helper (left). Dauster is Alma Wuesthoff's grandfather.

Crewman Hans Tonnesen prepares to toss a rake overboard to dredge the bottom for blue claws. The crabs, fattened for cold weather, dig themselves into the ocean floor for a winter's sleep. The rakes would, at times, bring up more than crabs, including barnacle-covered liquor bottles. The time is 1937.

Captain Arthur Lindland pauses from the rigors of crabbing with a refreshing bottle of brew. He typically left port at 5 am, at times not returning until the next day. An excellent day's haul was 75 to 100 bushels, worth $1 to $2 per bushel in the 1937 market, when retail ranged from about 50¢ to $1 per dozen. The captain is the father of Alma Wuesthoff, who lent the picture.

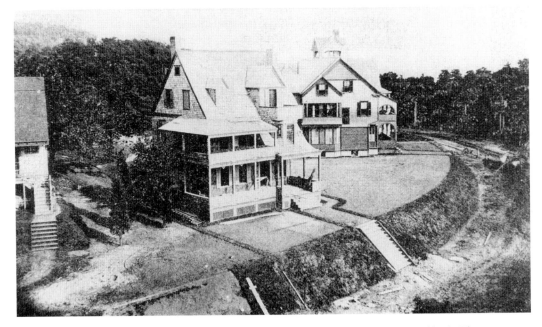

This view of Prospect Avenue is from the 1892 Board of Trade publication, *Atlantic Highlands*. The street is the small circle on the bottom of p. 121. Prospect Avenue today is a mix of preserved houses from the late nineteenth century and relatively recent additions.

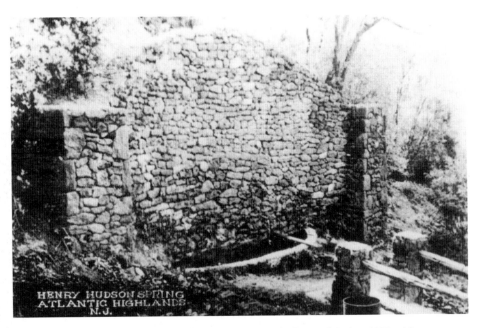

H.N. Lawrie of Washington, D.C., donated property to the borough in late 1935 with a condition that it be improved and maintained by the borough. By the following June, the D. A. Caruso Construction Company began excavation to construct a grotto for a site to commemorate Henry Hudson's spring. Work was swift and finished that summer, with much of the funding paid by the Atlantic Highlands Lions Club. This view is from a *c.* 1940 postcard.

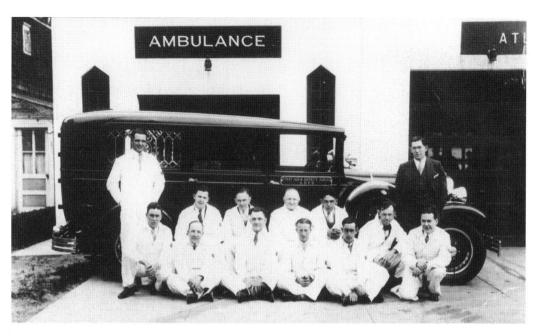

The First Aid and Safety squad was founded in 1930, with a wing then added to the fire house. Posing in front of their new ambulance are: (first row) Charles Huber, W.H. Posten, Morris Joslin, Edward Munn, Peter McLaughlin, and Leslie Antonides; (second row) Edward Gehlhaus, Norman Olson, William Gerkins, and Edmond Blom; (standing) Arthur Irwin and Dr. A. Rosenthal. (Collection of the Atlantic Highlands Historical Society.)

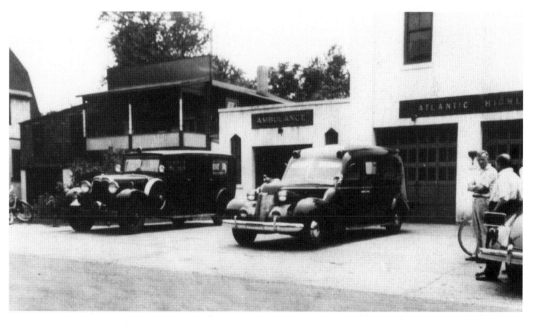

A new ambulance brought out a photographer *c.* late 1930s. The building left of the one-story wing was taken down some time ago, while a corner of a still-standing office is barely visible. (Collection of Atlantic Highlands Fire Dept.)

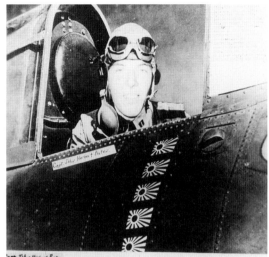

Left: Captain John Herbert Posten, a graduate of Atlantic Highlands High School, enlisted in the Army Air Corps in April 1941. He was assigned to Manila and earned distinction early as an ace by his destruction of five Japanese warplanes. Posten received a hero's welcome and a parade on November 9, 1942, when he returned to his parents' Memorial Parkway home with his new bride, the former Margaret Christian of Montgomery, Alabama. This view is a World War II recruitment photograph.

Below: This *c.* 1890 view west from Prospect Avenue, another from the 1892 Board of Trade promotional booklet, *Atlantic Highlands*, is opposite the view on the top of p. 86, which shows the hill in the background. Here the low-lying lands looking toward Middletown Township beyond are viewed from the top of the hill.

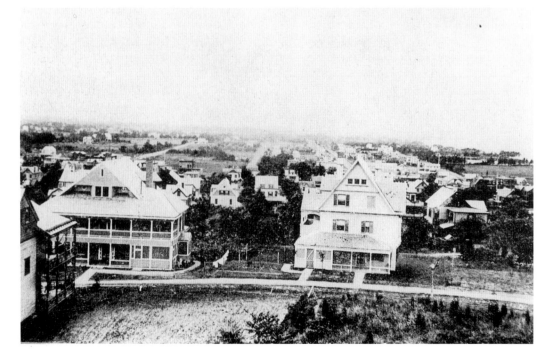

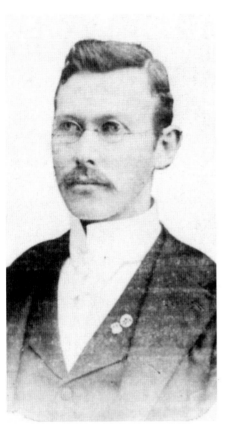

Right: Charles R. Snyder was born in 1869 in New Monmouth, Middletown. He became a lawyer in 1892, specializing in title and real estate work. Snyder held many municipal and civic appointments, serving 1916–19 as mayor and at least two years in the New Jersey Assembly. He organized the Kenasburg National Bank in 1913 and was longtime secretary and attorney for the Atlantic Highlands Building & Loan Association, rarely missing a meeting for forty years. Snyder married Earline D. Spader in 1894. They were the parents of Earle S. Snyder and Elizabeth S. Neill. Although he suggested his initials "CRS" stood for capable, reliable, senator, his 1917 campaign for the New Jersey Senate was unsuccessful. This picture is from a turn-of-the-century assembly campaign card.

Below: The rapid construction of the Earle Naval Weapons Station in 1943–44 in Middletown and Colts Neck is well known. Less familiar is the speedy acquisition of ownership of the land, performed by the Snyder, Roberts & Pillsbury law firm. Their title affiliate, aided by two outsider title searching experts, obtained the contract by competitive bid and completed 583 searches in record time. The partners of the firm are: (seated) John M. Pillsbury, Howard W. Roberts, and Sverre Sorenson; (standing) Watson W. Kern, Mrs. E. Cline Van Brunt, Miss Mary Carroll, Mrs. James Marvin, Miss Jane Lockhart, Mrs. J. Francis Rauch, Mrs. Etta Lockhart, Miss Marie Hillyer, Mrs. M. Earle McCullough, and Reverend M. Earle McCullough. Elizabeth McCullough, Howard Roberts' daughter, lent the picture.

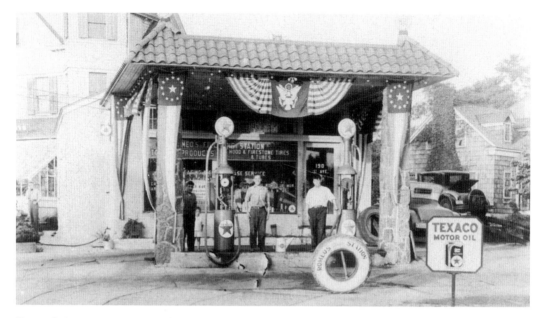

Romeo's Service Station was at the southeast corner of First Avenue and Valley Drive. A section of the latter was built into the Memorial Parkway in 1927, a 60-foot wide stretch of concrete road from First Avenue east to the borough boundary. The bunting and age of the original photograph in the collection of the Atlantic Highlands Historical Society suggests this picture was taken at the dedication of the road on November 11, 1927.

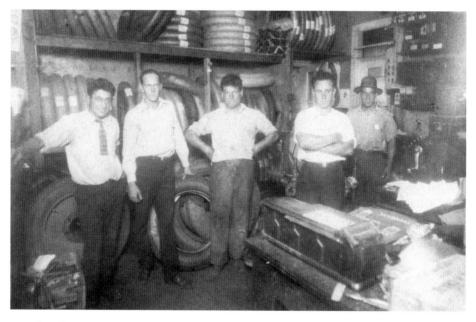

A well-stocked inventory of tires was a necessity in Romeo's Service Station. They moved well, with Joe Romeo having won in 1929 a sales contest among 497 participating Goodyear dealers. He was awarded with $100 in gold and a trip to Akron. (Collection of the Atlantic Highlands Historical Society.)

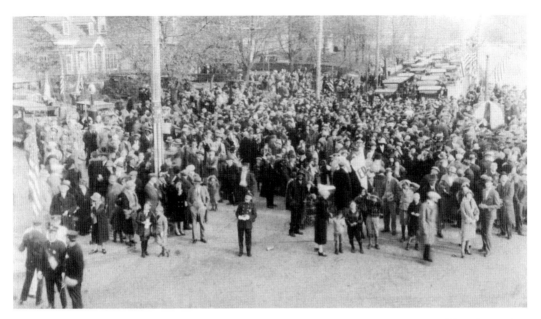

The November 11, 1927 dedication of Memorial Parkway was attended by a crowd of four thousand. A mile-long parade opened the proceedings. In the median strip, twenty-one ornamental light poles and eleven flag poles were erected. A monument at each end was mounted with a bronze tablet designed by L. Jerome Aimar inscribed: "Memorial Parkway; Dedicated to the Memory of the Citizens of Atlantic Highlands Who Served Our Country in the Great World War; Erected by an Appreciative Community Through the Initiative of the Lions Club of Atlantic Highlands." One of these monuments now stands in the First Avenue jug-handle. Noted Red Bank aviator Jack Casey and an army airplane flew over the crowd, one of them likely taking this picture. (Collection of the Atlantic Highlands Historical Society.)

A late 1920s view of the Romeo residence, greenhouse, and a rear corner of their garage-filling station on First Avenue at its juncture with Memorial Parkway. What made the greenhouse special? In 1929, a banana tree produced a bunch of fruit. (Collection of the Atlantic Highlands Historical Society.)

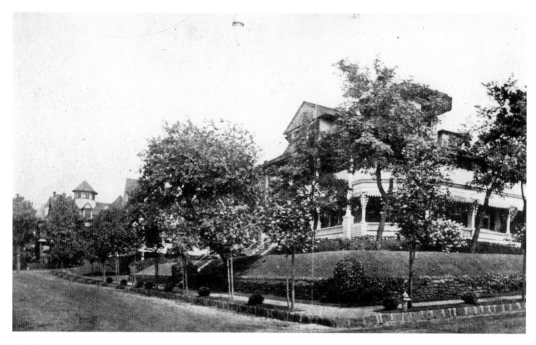

The house on the corner is 48 Seventh Avenue, a street that maintains its character eight decades after this postcard was published. (Collection of the Atlantic Highlands Historical Society.)

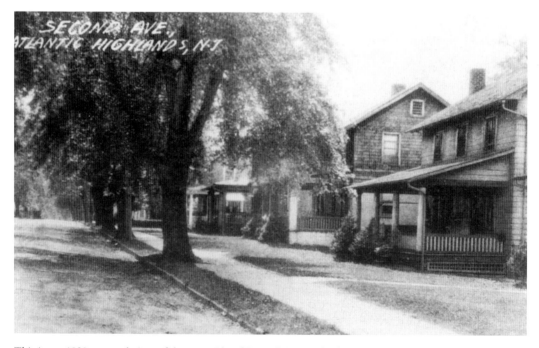

This is a *c.* 1920 postcard view of the west side of Second Avenue looking south, a short distance from Ocean Boulevard. No. 3 and 5 Second Avenue are readily recognizable today, with their porches now enclosed.

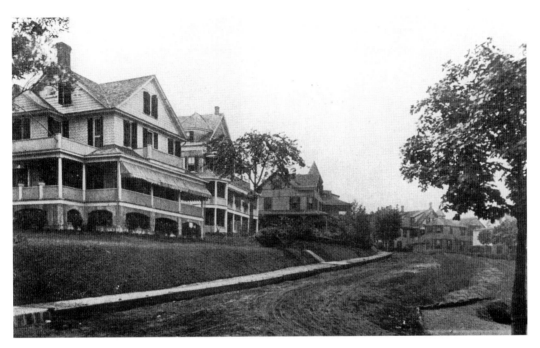

Fifth Avenue is a one-block, dead-end street, the shortest arc on the circle, running from Ocean Boulevard to the rear of the properties on the east side of Fourth Avenue. This is a *c.* 1912 postcard view. (Collection of the Atlantic Highlands Historical Society.)

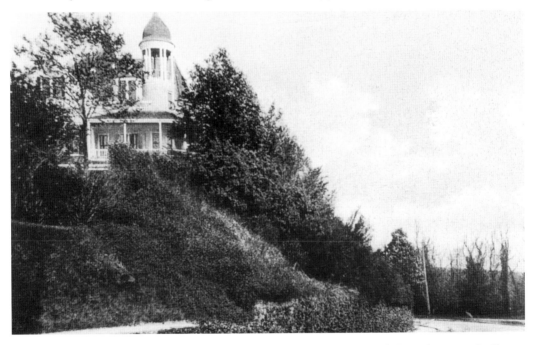

The Straus House is shown here from Eighth Avenue in a *c.* 1910 postcard. It was known as the Tower House in the 1890s. The tower, now enclosed, appears to have been an open balcony. (Collection of John Rhody.)

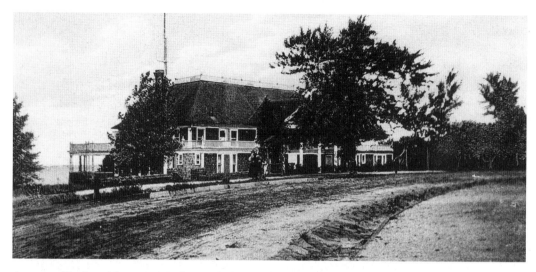

A group of leading citizens organized a social club in 1895 known as the Atlantic Highlands Casino. In January 1896 work began on a clubhouse, which was formally opened on July 4, 1896. The Casino was designed by Frank T. Lent in competition with fellow Atlantic Highlands architects Thomas J. Emery and Harold Montayne. The site consisted of three lots on the north side of Ocean Boulevard, near the former locale of the Grand View Hotel. The ballroom was the principal interior facility; bowling alleys were also installed. The place was later occupied as a restaurant, known alternately as the Scenic Inn and the Casino. It was destroyed by fire on December 15, 1954. A private residence is on the site at 100 Ocean Boulevard. (Collection of the Atlantic Highlands Historical Society.)

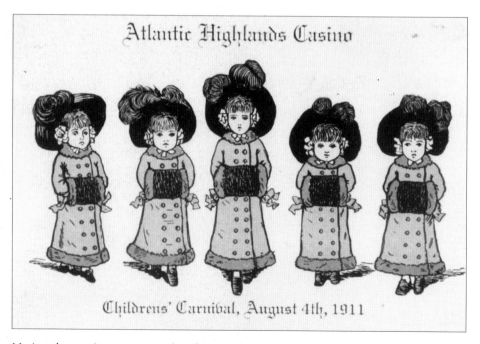

Music and entertainment were staples of Casino activities. Friday nights were long-devoted to children's events. This carnival was a dance. The primary features were waltzes and two-steps, but they also included one barn dance and a number called the "Paul Jones."

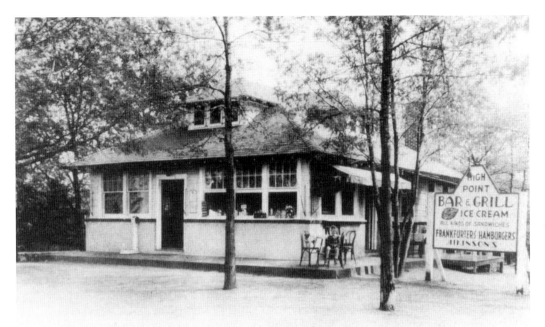

ATLANTIC HIGH POINT BAR AND GRILL, OCEAN BOULEVARD, ATLANTIC HIGHLANDS, N. J.

Above: The High Point Inn had a 444-foot frontage on Ocean Boulevard. This postcard view dates from *c.* 1940, about the same time the estate of Otto Koenig sold the place to William Riniger of Neward. (Collection of John Rhody.)

Right: Mayor Waldron Smith is shown at the final whistle blowing in April 1950 at the Jersey Central Power & Light Co. plant. Daily soundings at 7 am, noon, 1 pm, and 5 pm were a long tradition at the municipal facility until 1925, when the plant was sold to a private utility. The soundings stopped, as it became too costly to maintain the natural-gas-fired boiler at 125 pounds of pressure just for the whistle. (Collection of the Atlantic Highlands Historical Society.)

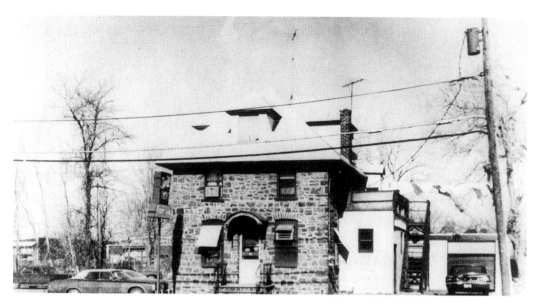

John Rosse opened Jack's Inn, an Italian restaurant, on First Avenue in the 1930s. It was moved to a peanut stone former residence on the north side of Highway 36, remaining there until the business closed in 1986. The structure was a rare example of an entire building made of this material, making its demolition a regrettable loss.

Tony Natale's White Crystal Diner at 20 Center Avenue, a 1960 work of the Kullman Dining Car Company of Newark, rapidly became a local landmark. A Natale restaurant has been in town ever since the 1920s, when boarders were taken at their Bay Avenue place. This diner, opened by Tony's father Joe after a stay in a diner on Highway 36 in Leonardo, is a fifteen-stool, shortened version of the classic streamlined style that long gave character to New Jersey's highways.

Henry Sculthorp of Highlands built the Log Cabin Inn restaurant out of South Jersey cedar logs in 1929. Most of the building was taken up by the main dining room, with the place also having three private dining rooms in addition to a kitchen. It was located on approximately 2.5 acres around the site of today's Mount Mitchill Park. The Sculthorps sold the business to Dr. Howard Weicher of Union City in 1944. This *c.* 1940 view post-dates the expansion of the original 52-by-26-foot building. The Log Cabin Inn was under the latter's ownership when destroyed by fire on December 26, 1953. A rebuilt inn was demolished in 1974 for the park. (Collection of John Rhody.)

This *c.* 1921 view of the Lily Tea Room reflects a spacious and comfortable dining establishment. The tea room was developed in the early years of motoring to cater to the family trade as opposed to the rough and ready character of many roadside eateries. (Collection of John Rhody.)

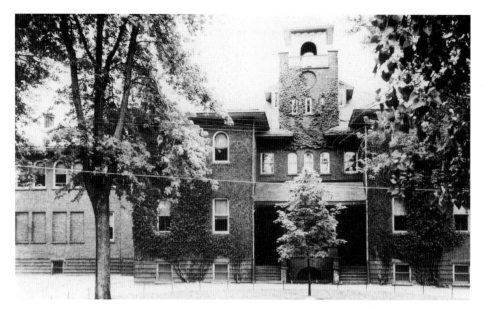

Atlantic Highlands' first school on Avenue C was rapidly outgrown. Designed by Atlantic Highlands architect Harold Montayne, this school was built in 1895 on the block between Washington and Lincoln Avenues, set back about 350 feet east of First Avenue. Although it was not quite finished, the building was dedicated on January 4, 1896, and occupied three days later. It was hailed for its spaciousness, with a third-story auditorium seating four hundred. Classrooms were arranged around a central court with single desks for thirty-five to fifty pupils. There was no graduation in 1900 as the twelfth grade was added in the fall of 1899, advancing the completion of schooling one year. This view is from Washington Avenue. A *c.* 1907 expansion on the southeast is visible at left.

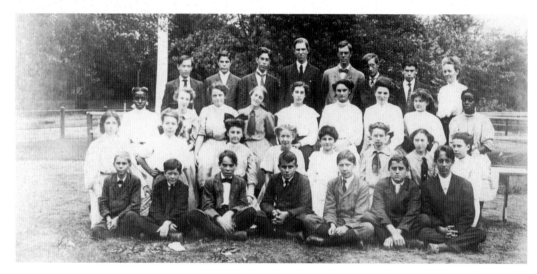

The ninth grade of the first Atlantic Highlands school in 1907. Although the unhappy faces probably reflect photo-posing practice of the time, the careful historian looks for other reasons, such as their spending the year jammed in a classroom intended for thirty-five to fifty pupils, as noted above. (Collection of the Atlantic Highlands Historical Society.)

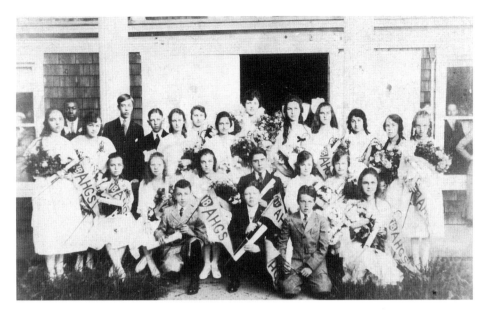

The Atlantic Highlands Grade School graduation in 1918 appeared to be a festive affair, held at the Casino. Why do the girls so outnumber the boys, who were certainly too young to be off to the Great War? (Collection of the Atlantic Highlands Historical Society.)

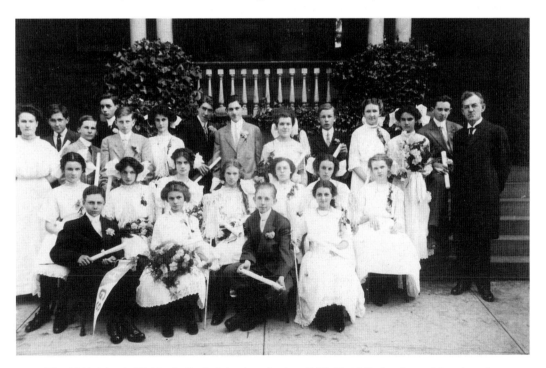

The 1911 Atlantic Highlands Grade School graduation. Edith Todd Ogden donated her class picture to the Atlantic Highlands Historical Society; unfortunately, no identifications were included.

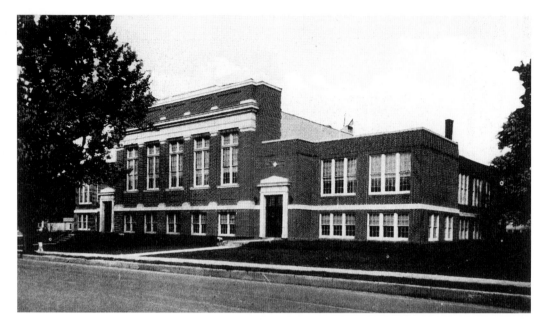

One wonders if planners of the 1896 school (see top of p. 106) set back the building with the forethought of a replacement school being built closer to the street. It happened in the early 1920s, with an expansion on the Washington Street side completed in 1941. After years as a combined grade and high school, the building was and is exclusively a grade school after the 1962 opening of Henry Hudson Regional High School. (Collection of Ed Banfield.)

Classrooms in the new school were designed for twenty-five to thirty students, relieving recognized crowded conditions. These students had plenty to be happy about: the classrooms were spacious, fresh air was blown in by special ventilators, and there were large windows and bright electric lights—all features outlined in a late 1920s picture album describing the school, generously lent by Michael Cassone.

The school library appears to be well-stocked in the late 1920s.

George Wuesthoff and his students enjoy an ice cream party to celebrate a successful yearbook ad sales campaign. At this time Wuesthoff was a social studies teacher and senior class advisor; he would later become a longtime principal and superintendent of schools. The time was the early 1950s, when skirts were longer and life simpler. One admires the youthful exuberance over ice cream, an event that might cause some of today's jaded youth to inquire, "Where's the party?"

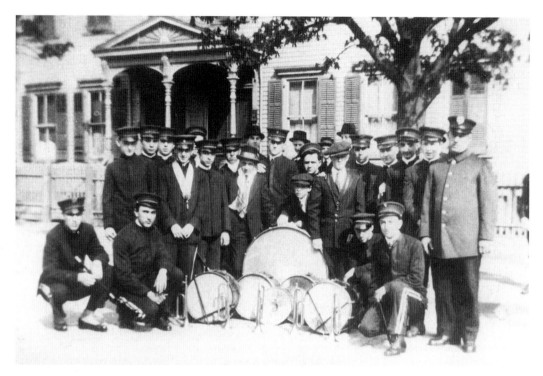

An unnamed band makes a striking, if anonymous, pose around the turn of the century.

The Atlantic Highlands High School Band was well-equipped to play c. 1930. They were guided by their principal, Herbert Meinert (in front with the trombone). Seated at the piano is Bob Brittingham. Others are: (in front) Alice Augustine, Ruth Zelyer, Richard McHenry, Bill Brittingham, and Albert Waltz (at the drums); (standing) Meredith Bell, James Reilly, Robert Bahr, Margaret Armstead, and the teacher, Miss Imlay.

President Theodore Roosevelt visited the New Jersey National Guard Camp at Sea Girt on July 24, 1902, by sailing from Oyster Bay, New York, via the Long island Sound, East River, and New York Harbor. The president's ship, the *Mayflower*, had a 19-foot draft and could not dock. A launch took the president to Atlantic Highlands, where a special train was waiting for a rail trip down the Monmouth shore. He was greeted by Governor Franklin Murphy and an array of political and military dignitaries, including Senators Kean and Dryden. The president is at center, with the governor a half-step behind. The account in the *New York Times* the next day indicated that presidential crowd control was not yet a perfected art. Roosevelt's party departed from Atlantic Highlands later in the day. (With thanks to Joann Strano, reference librarian, Middletown Township Public Library.)

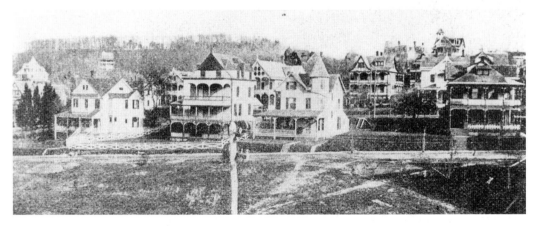

The caption for this image from the 1899 Emery booklet reads, "View from Fourth Avenue at the Bay showing some of the cottages for rent," creating the impression of a fine collection of well-built attractively finished houses in a close, waterfront setting. One suspects the view was taken from an undeveloped spot on the west side of the street looking up the hill.

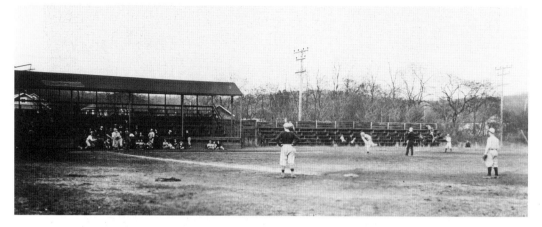

The ball field in the southwest section of town near what was Valley Drive, used for a variety of events, had its most notorious moment when Babe Ruth and two New York Yankee teammates, Herb Pennock and Waite Hoyt, visited in October 1926. They ran late and had to omit a planned talk to the school children. Ruth and stars played the Highlanders to a 7–7 tie, the Babe going four for five, with two homers and a pair of singles. The stadium was torn down *c.* 1940 and is now the site of Columbia Houses and the Capri Apartments.

The Atlantic Highlands Alerts were known for producing some fine ballplayers and for being the only area team with a logo resembling a character of the Chinese alphabet. They are: (front row) J. Stewart (SS, RF), C. Stryker (1B), J. Stryker (mascot), E. Sweeney (C), and N. Crawley (2B); (back row) W. Bills (LF), W. Woodward (3B), R. Johnson (P), G. Stryker (manager), J. Hopla (P, RF), S. Stryker (SS, P), and R. Stryker (CF). Sterling Stryker, nicknamed Dutch, had a brief career in the major leagues. He had a 3–8 record pitching in twenty games for the 1924 Boston Bees, and no decisions in two games for the 1926 Brooklyn Dodgers. This picture is *c.* 1915. (Collection of the Atlantic Highlands Historical Society.)

This photograph shows the Atlantic Highlands 1928–29 girls basketball team, apparently at the high school level. The youths seem energetic and eager enough to conduct a game more vigorous than the two dribbles and pass, half-court variety played then.

The members of the Atlantic Highlands High School basketball team for 1925–26 were: (kneeling) Fred Waters, John Pillsbury, and E.P. Mason; (standing) Jimmy McLaughlin, Kid McLaughlin, Coach Hesse, Charlie Dato, and Calvin Spain. It was fitting for John Pillsbury to be holding the ball, as he later figuratively "carried the ball" so capably for many years as borough attorney. (Collection of the Atlantic Highlands Historical Society.)

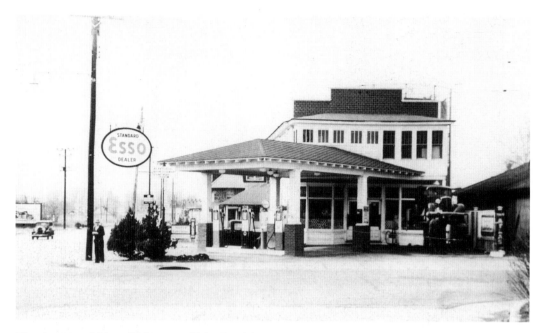

The character of this *c.* 1930s scene of John Brazile's service station at the northwest corner of Highway 36 and First Avenue differs considerably from the present situation. The road was then a single lane in each direction, with less traffic. A glimpse of the house that was later Jack's Inn is visible in the center background.

A view to the northeast on Highway 36, west of First Avenue, shows the border with Middletown Township and the framework of an empty gas tank. The watermelon sign—on the Middletown side—is in the old highway tradition of eye-catching structural statements.

Above: Looking to the northeast around Highway 36, from First Avenue just south of the road, the landscape was dominated by a well-filled tank. A 1925 ad, run the year the largest gas tank of the County Gas Co. was built, reflected their progress with an illustration of tanks, along with their dates and capacity. Three tanks, with capacities of 50,000, 200,000, and 750,000 cubic feet, were erected in 1910, 1914, and 1925 respectively. This is likely the latter.

Right: Nesting fish hawks have long fascinated viewers. This scene is from a *c.* 1910 Atlantic Highlands postcard. Their nest sites today are similar, although they are now more likely to be found in Sandy Hook rather than the built-up borough. (Collection of John Rhody.)

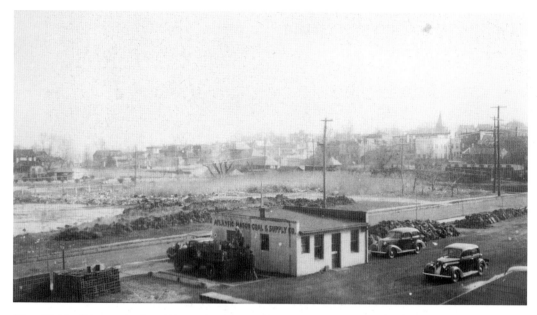

West Highland Avenue in the 1930s was hardly developed. The railroad station in the context of its surroundings is shown in the center of the picture, while the old Methodist steeple can be seen in the skyline at right.

The building of an athletic field was a major improvement of the borough's recreational facilities. This construction scene dates from 1947 and shows the view on the south side of Highland Avenue, at the foot of Washington, with the old gas tanks to the east providing a point of reference. The property was purchased by the Atlantic Highlands Fire Department, with the field known as the Firemen's Memorial Athletic Field. It is readily visible at the top of the next page.

This aerial view, looking to the northeast, dates from the late 1960s, following the November 1966 end of passenger rail service, and prior to the demolition of the borough hall block. A recently-dualized Highway 36 is in the lower right corner, while the 1964 Highlandia apartment complex at top left marks the start of Ocean Boulevard.

This view looks southeast from a point over the shore west of the pier with the Navesink River at center left. The grade school in the center and the former gas tanks at right are the most prominent landmarks, with First Avenue running diagonally from the lower left. Note the trains laid up beside the 1952 station.

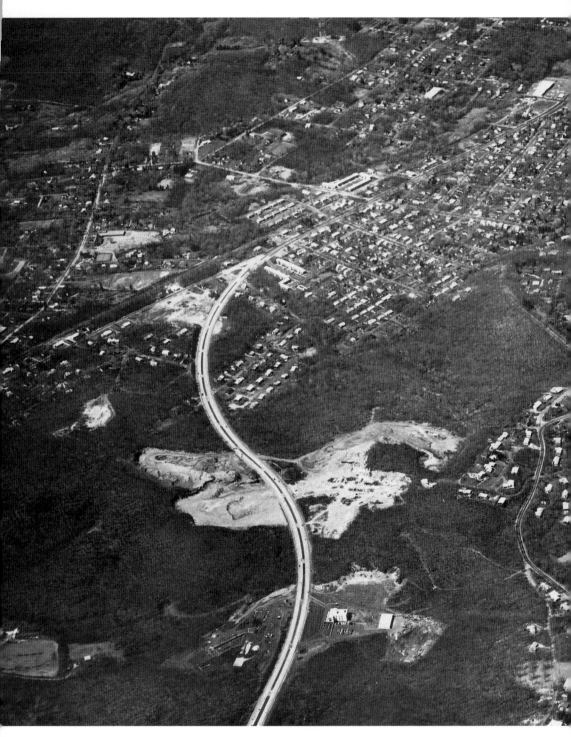

Nearly all of the borough is visible in this 1970s aerial view. The breakwater at right is the most easily identifiable. Above it are the pilings of the destroyed pier, while the oil tanks are barely visible at top. A filled gas tank can be spotted near the page divide. The wide band at left is Highway 36, with the

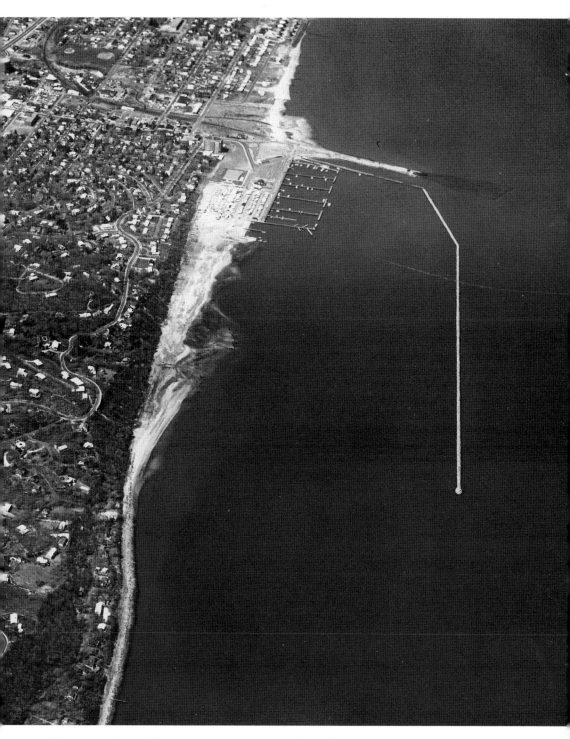

Clearwater Swim and Cabana Club at bottom—a thriving facility then. Ocean Boulevard makes its winding path following the contour of the hills, most clearly visible near the center beside the dark hillside greenery. Note the sand-gravel fields at center-left. Middletown Township is on the upper left section.

The 1941 addition to the grade school is clearly visible in this 1950s aerial view north from Garfield Avenue. The borough hall and park-bank blocks are filled-in with their older buildings, about in the center of the picture. The 1952 railroad station is in place, at left.

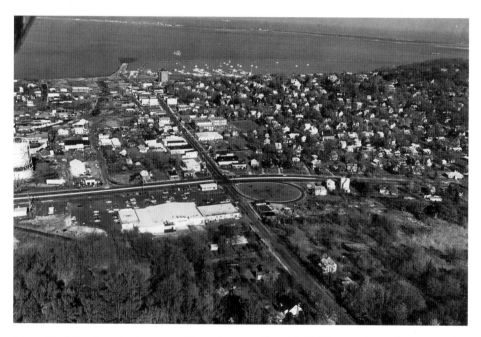

Many Mind Creek marks the borough's southern border with Middletown Township. It is visible at center-left, but its path across the center of the photograph is not. The First Avenue jug-handle of Highway 36, a blank circle in the center, is a discernible landmark. Sharp eyes will spot the grade school and borough hall on the east side of First Avenue, and the Central Baptist Church in the densely-built section on the right. The Highlandia and the harbor are at top.

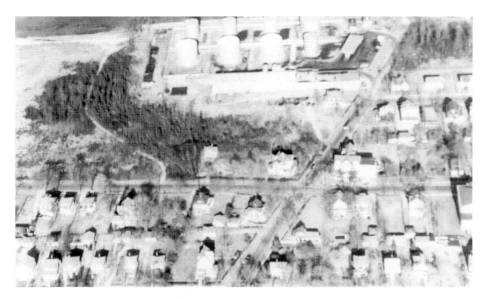

In 1929, interests for Standard Oil bought 18.5 acres on Sandy Hook Bay, bordered by Center Avenue, Avenue D, and Wagner's Creek, formerly the site of Colonel Frederick Benson's old house. They quickly pushed approval for a tank farm through the borough council, claiming great local economic benefit through wages and purchasing power. Opposition mounted, litigation ensued, and obviously the oil party won, with the plant built in 1930 on a part of the plot. Although economic projections were overstated, the facility provided some economic benefits during the ensuing depression. However, the tanks were not missed after they were removed in the early 1990s and part of the land was improved for park use.

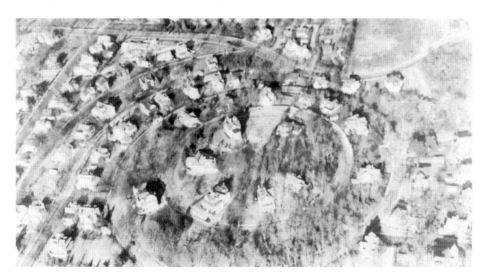

Ocean Boulevard runs along the top of this c. 1940s aerial view, with Fourth Avenue the long, straight street at left. Prospect Avenue is the smaller full circle, while Eighth Avenue is the wider full-circle street. Note the Straus House between the two, with its pointed tower, just off left-center. The houses on the bottom of p. 73 are between the circles, left of the twelve o'clock position. The short arc that forms a triangle with Fourth and Ocean Boulevard is Fifth Avenue (see top of p. 101).

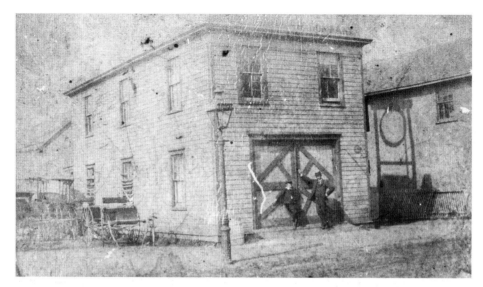

The old firehouse on the north side of Center Avenue was completed on April 27, 1883, according to Dr. H.A. Clark's list in Leonard, after a Skinner-patent extension-ladder truck costing $475 was purchased (it is now pictured on the department's insignia). Located behind the Morrell stores on First Avenue (see p. 46), the building was known as "the truck house" and contained borough offices on the second floor. The carriages at left were at D. Lane Conover's livery stable next door. The two men are unknown. The building was sold to John Burton, whose plans to install a restaurant there were thwarted when the premises were ruined by a fire on August 26, 1930, at the adjacent Depot Garage and Central Restaurant. (Collection Atlantic Highlands Fire Department.)

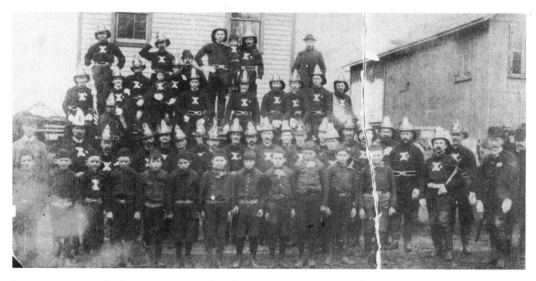

The combined fire departments of Navesink and Atlantic Highlands paraded November 28, 1889, posing in front of the truck house shown above. A boy's brigade was organized for the occasion. William A. Sweeney, the boy at front right, was editor of the *New Jersey Standard* when he published this picture on May 28, 1909, providing identifications and some up-dates on their lives. (Collection of Atlantic Highlands Fire Department.)

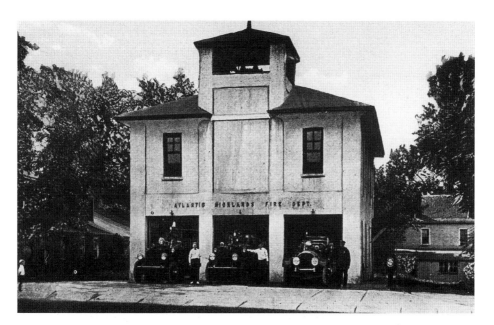

A firehouse to garage the borough's three companies was built on the south side of Mount Avenue in 1917. Designed in an Italian Renaissance Revival-style, architect unknown, the building was a forerunner for the flat, stuccoed exteriors that characterized much of 1920s local construction. A wing for the first aid squad's ambulance was added in 1930. The building in this late 1920s postcard was demolished on February 12, 1996, to clear the site for a new firehouse.

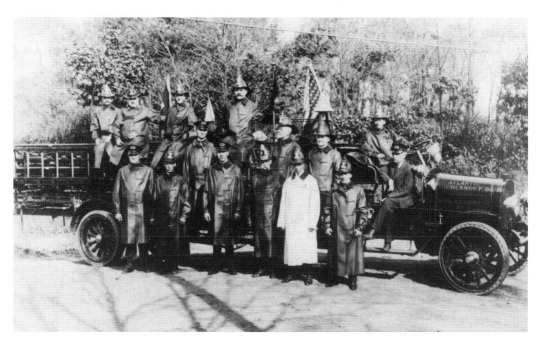

A *c.* 1920s photograph of the Atlantic Highlands Hook and Ladder Co. No. 1. Usually photographed in dress uniform, firemen in their slickers command a second look. (Collection of the Atlantic Highlands Historical Society.)

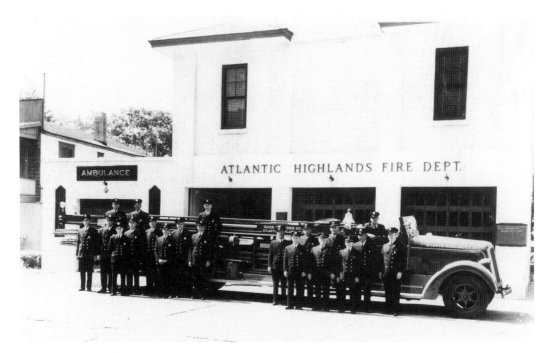

Hook and Ladder Co. No. 1 in the mid-1950s.

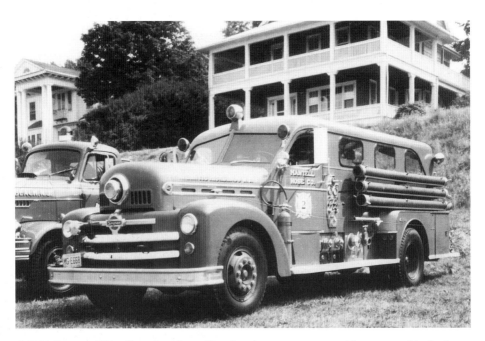

A 1952 Seagrave 750-gallon-per-minute Detroit sedan-type pumper, with an unusual body that had an enclosure for hose equipment and personnel. It was developed for the City of Detroit to help with winter weather extremes, and was available to other departments, but few were sold elsewhere. It was a design ahead of its time, as modern fire engines are typically enclosed. (A William Schwartz photograph lent by John Rieth.)

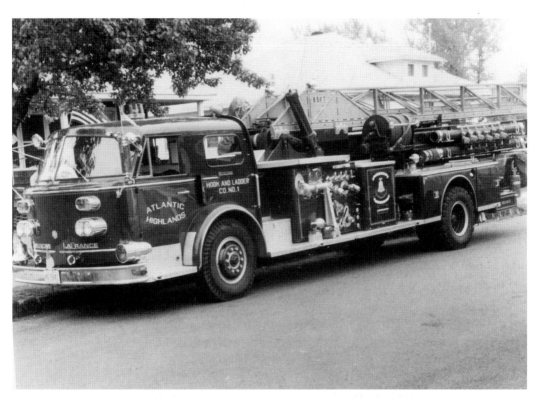

Above: Hook and Ladder Co. No. l's 1966 American La France 85-foot aerial ladder truck, in service until 1983. The need for longer ladders reflected the lack of accessibility in many parking lots and around hillside properties. (A William Schwartz photograph lent by John Rieth.)

Right: The Central Baptist Church had its origins in a plan to locate a Sunday school east of the railroad, accomplished in 1892. Eastsiders formed an independent church the next year, erecting the Romanesque Revival edifice in 1894 at the northeast corner of Third and Highland Avenues. The architects were Weary and Kramer of New York. The church is shingle-clad, with a 72-foot square tower in the southwest corner of the building. Stained glass is extensive throughout. The church was dedicated on December 28, 1894. This postcard view is *c.* 1940.

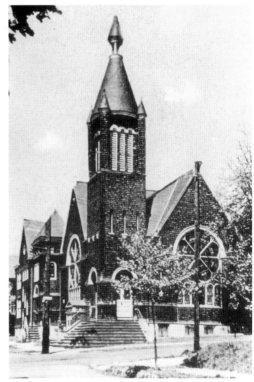

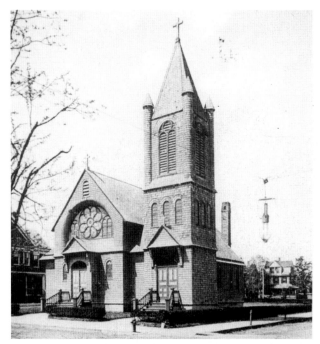

The old frame St. Agnes Roman Catholic Church was built in 1891 at the northwest corner of South Avenue and Avenue C, behind the present church at the southwest corner of Center Avenue and Avenue C. It was designed by John J. Deery and built by Michael Moran of Long Branch. One or both did flawed work, as in 1896 the tower was removed and rebuilt, while the church was shored up with sidewalls, straightened, and tie-rods placed in the roof truss. This work was planned by Jeremiah O'Rourke, arguably New Jersey's premier Catholic architect of the time. The church, shown here in a *c.* 1905 postcard view, was taken down with the 1954 completion of the present brick church.

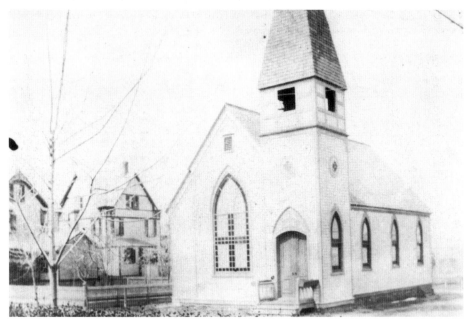

The Presbyterian Church was organized in Atlantic Highlands on December 19, 1890, and first met in White's hall. The lot at the southwest corner of Third and Highland Avenues was purchased in May 1891. Fund-raising began immediately, with the cornerstone of the Gothic Revival edifice laid on April 29, 1892, and the church dedicated on July 24, 1892. The builder was John Geary, with the churchmen digging the foundation and John Wells contributing the mason work. This view is *c.* 1890s. An entry porch and parsonage were built later. The latter was connected to the church. (Collection of the Atlantic Highlands Historical Society.)

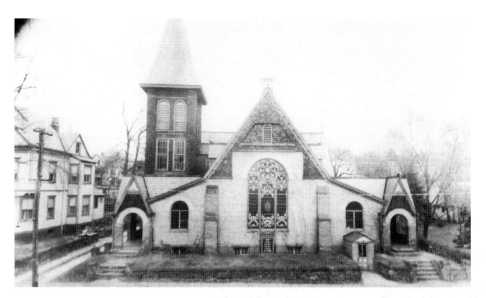

The Methodist Church was organized in Atlantic Highlands in 1881, erecting a frame church on the southeast corner of First and Mount Avenues in 1883. A yellow-brick edifice costing $30,000 was built on the east side of Third Avenue in the middle of the block between today's Ocean Boulevard and Mount Avenue, and was dedicated on November 25, 1894. The contractor was W.C. Cottrell of Asbury Park, one of five men who fell from a scaffold that June. The tall tower, long a widely visible Atlantic Highlands landmark, contained bell chimes.

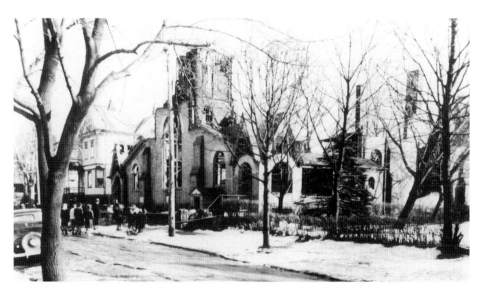

The Methodist church was destroyed on Saturday night, February 10, 1945, when a fire was discovered by the Reverend Roy E. Williams Jr., who lived in the adjacent parsonage . The roof and much of the steeple collapsed during the fire, which had gained considerable headway before being discovered. The standing walls were later demolished. Firemen saved the parsonage by applying a steady stream of water, their efforts aided by winds that were fortunately light. The underinsured church was rebuilt at Third and Garfield Avenues. A recently built house is on the site of the old church.

Why do these children look so unhappy? Did the photographer just tell them he was reneging on his promise of ice cream in return for a nice pose? Their identities are unknown in this photograph from the Carl De Cordova collection of the Atlantic Highlands Historical Society.

Carl De Cordova and sister play with a rabbit. Why does the bunny sit there? Is he tame or petrified? The time is likely the turn of the century. Keep those pictures coming for Volume II... (Collection of the Atlantic Highlands Historical Society.)